D0178876

INTRODUCTION

This book offers a choice of 50 different things for you to draw. Some are fairly simple and others more complex, but all are worth having a go at as exercises in drawing. Each project is broken down into steps to show the drawing process, followed by a page on which you can make your own version using my drawings as reference. Of course, once you have tried these subjects, 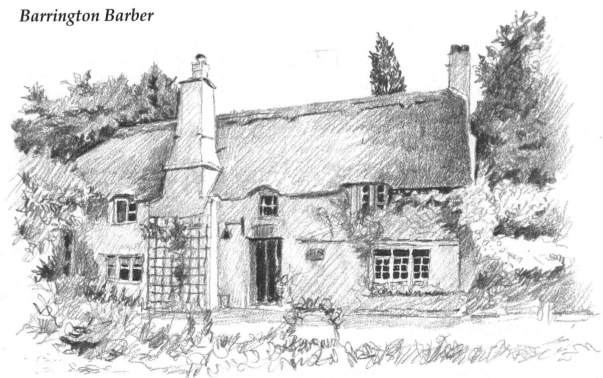 you may be inspired to tackle a few others of your own choice. That's the idea – all around us there are plenty of things to draw, and it's just a matter of deciding which ones you are interested in. Practice is the most useful thing in drawing, and the more you practise the more skilled you will be. So have a go and see how you get on. Good luck, and keep drawing!

Barrington Barber

EXERCISES IN HANDLING THE PENCIL

The mere feel of pencil on paper is part of the charm of drawing. Here are a few exercises to introduce you to basic techniques before you tackle the main part of the book. Exercises such as this are always useful to a draughtsman.

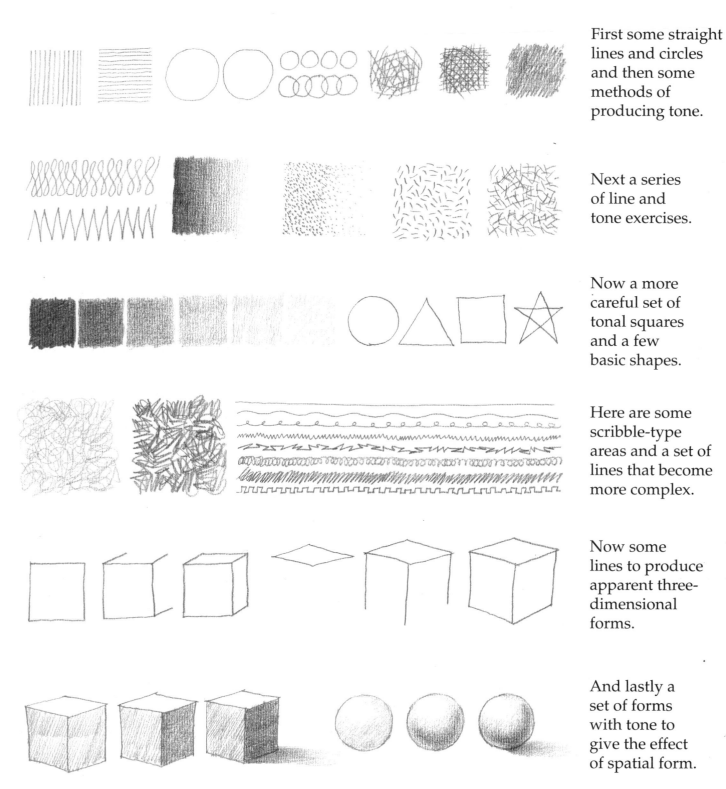

First some straight lines and circles and then some methods of producing tone.

Next a series of line and tone exercises.

Now a more careful set of tonal squares and a few basic shapes.

Here are some scribble-type areas and a set of lines that become more complex.

Now some lines to produce apparent three-dimensional forms.

And lastly a set of forms with tone to give the effect of spatial form.

PERSPECTIVE DRAWING

To make objects look three-dimensional you need to show them
diminishing as they recede from the viewer. This is done by means of
drawing a horizontal line that represents the horizon (your eye level)
and then constructing lines from the main shape that converge to meet
at a point on the horizon – the vanishing point.

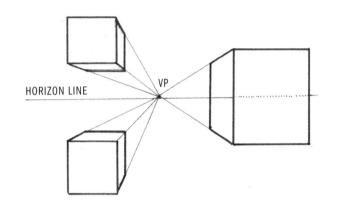

One-point perspective is used
when the object is facing directly
towards you.

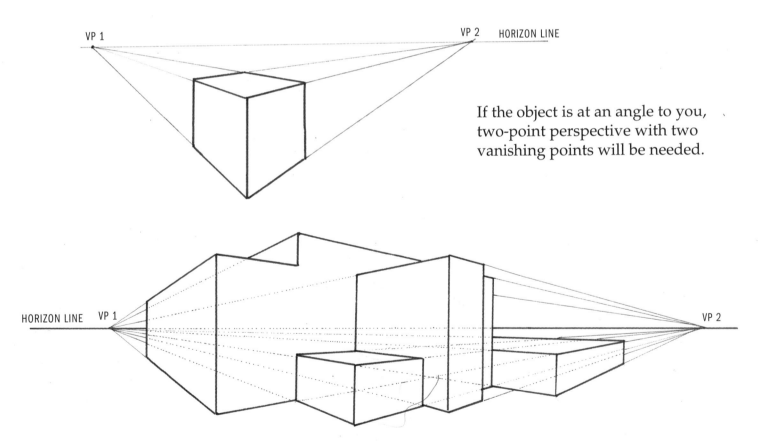

If the object is at an angle to you,
two-point perspective with two
vanishing points will be needed.

Here is a more complex attempt to construct a three-dimensional set
of forms to resemble buildings in space.

HUMAN PROPORTIONS
The Body

A normal human figure has about seven and a half head lengths in the full length of the body. This is an approximate measure and individuals will be slightly different.

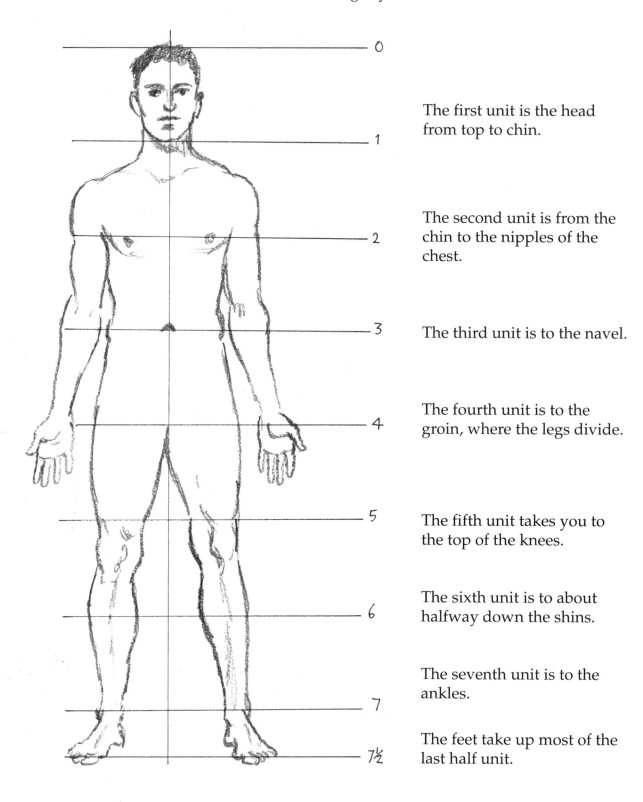

0

1 — The first unit is the head from top to chin.

2 — The second unit is from the chin to the nipples of the chest.

3 — The third unit is to the navel.

4 — The fourth unit is to the groin, where the legs divide.

5 — The fifth unit takes you to the top of the knees.

6 — The sixth unit is to about halfway down the shins.

7 — The seventh unit is to the ankles.

7½ — The feet take up most of the last half unit.

HUMAN PROPORTIONS
Human Head Measures

Most human heads are of the proportions below, with minor variations. The eyes are set halfway down the length of the head from the top of the skull to the edge of the chin.

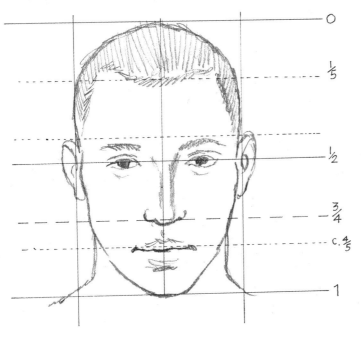

The hairline on the forehead is about one-fifth down from the top of the head.

The end of the nose is about three-quarters of the way down the head, halfway between the eyes and the bottom of the chin.

The mouth is nearer to the end of the nose than the bottom of the chin. It is about four-fifths down the head length.

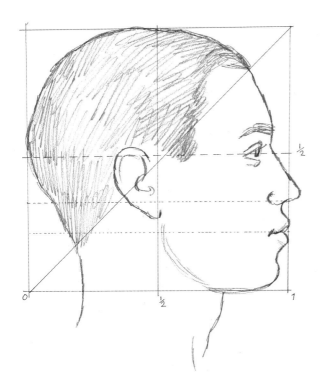

In profile the head fills a square shape, with the ear just behind the halfway mark.

The area of hair growth occupies the upper back part of the head, defined by the diagonal line from the top front to the bottom back.

The nose usually projects a little past the edge of the square.

These measurements are similar in people of all types. The minor variations that occur are usually in the fleshier parts of the face.

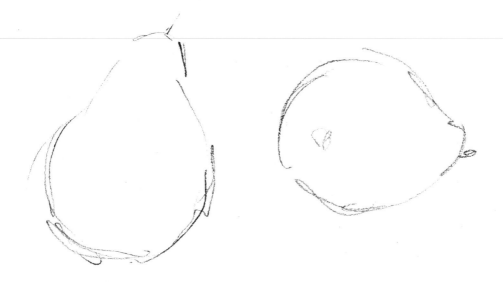

First draw a general outline of the pears, without being too definite.
Note that the shapes are not identical as the angle of view is different.

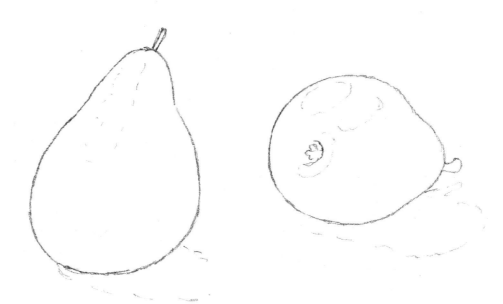

Then firm up the shape of the pears, making the outline more
precise. Put in an indication of where the light and shade fall.

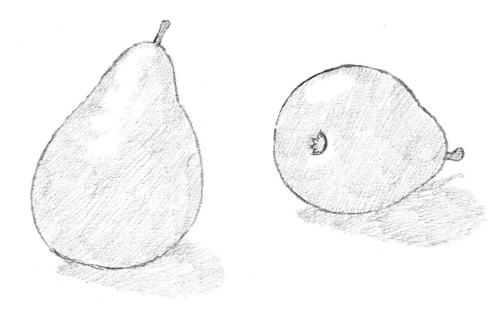

Now put in the main area of tone, or shading. This should be uniform in tone, the very lightest that you can make. Leave only the very brightest areas of light unmarked.

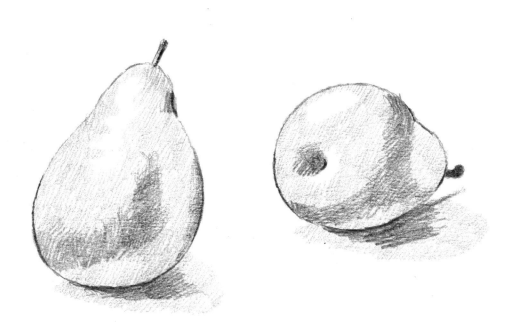

At this stage put in the darkest areas of tone, not forgetting the cast shadows on the surface that the pears are on.

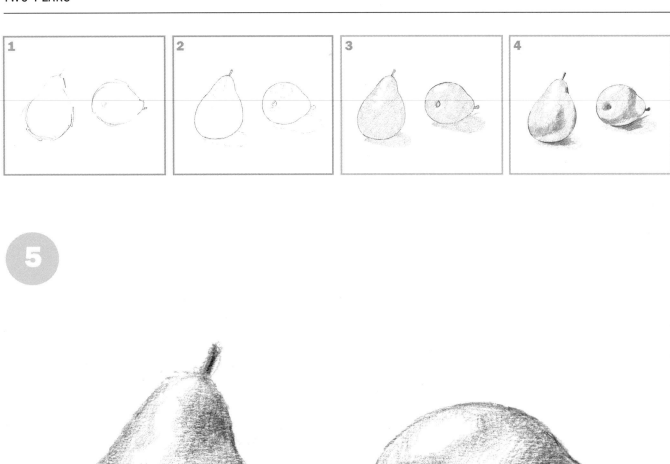

5

Finally, build up the intermediate tones that allow the darks and lights to gently fade into each other. Where there is a sharp outline, strengthen them.

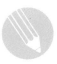 Varieties of fruit are good subjects to start your drawing practice with as they are easily obtainable and the forms are relatively simple.

1

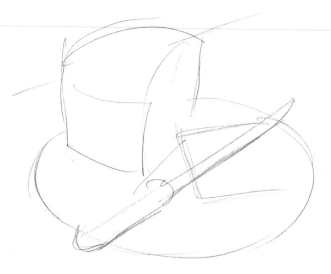

First draw the general shapes of the loaf, breadboard, slice of bread
and knife in fairly loose, lightly drawn lines.

2

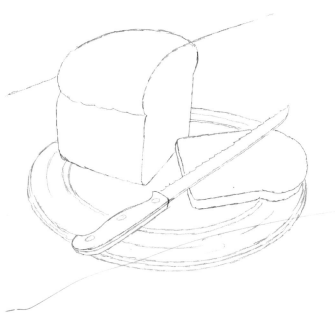

Next firm up the lines until you have a definite outline drawing of
everything in the picture. This is where you can erase any mistakes
until you have a good likeness of the objects, clearly drawn.

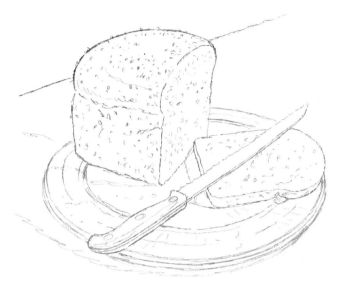

Now put in some marks that indicate the texture of the loaf and the grain on the breadboard.

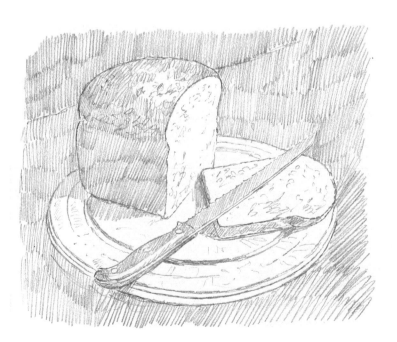

At this stage put in all the shading in one light tone. Every part that is going to have tone of some sort should be covered. Note the highlight on the knife handle that shows its smooth texture.

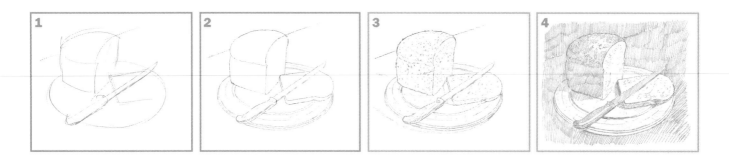

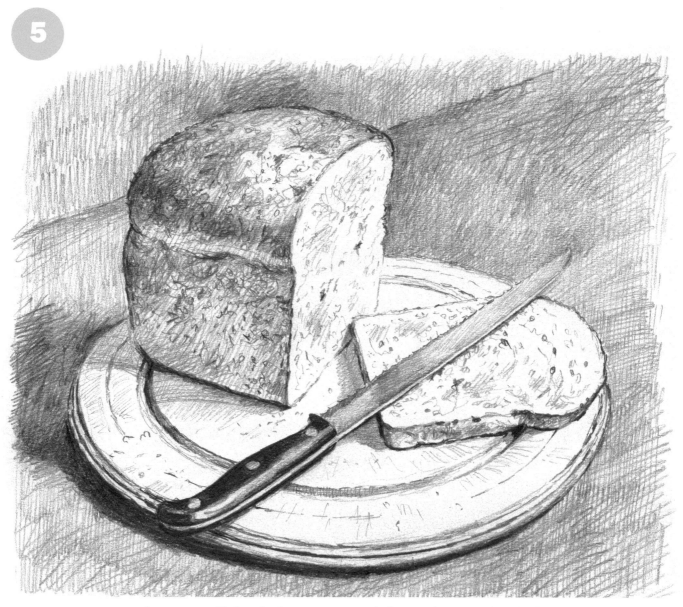

Lastly put in all the darkest tones and the mid-tones that help the
light and dark areas blend into each other.

The differences in texture of the interior and exterior of the loaf, the grain of the breadboard and the metallic surface of the knife blade give you plenty of chances to vary your pencil marks here.

A CABBAGE

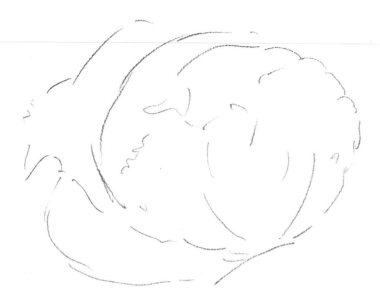

First, lightly draw a general outline of the whole shape of the cabbage, remembering that the leaves have uneven edges.

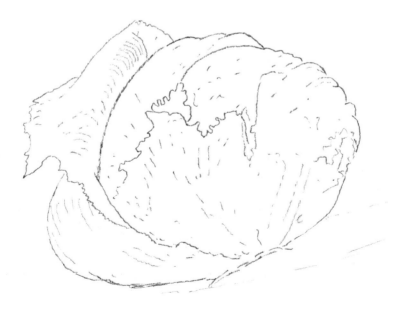

Next, carefully draw in the edges of the cabbage in some detail. Any necessary erasing can be done at this stage. Without being too fussy, try to put in everything that you can see.

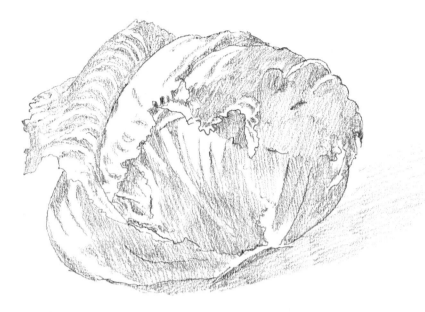

Now indicate all the shading on the cabbage and the cast shadow on the surface that it rests on. Leave white paper for the highlights only.

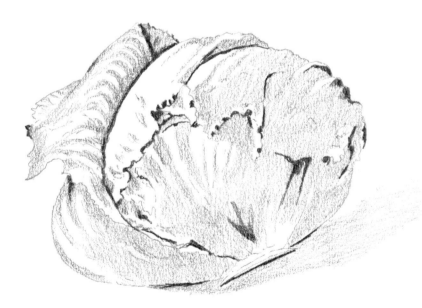

Put in any really dark areas firmly, making them as black as possible to show the deep shadows where the leaves curl.

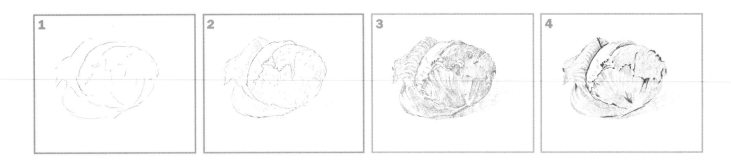

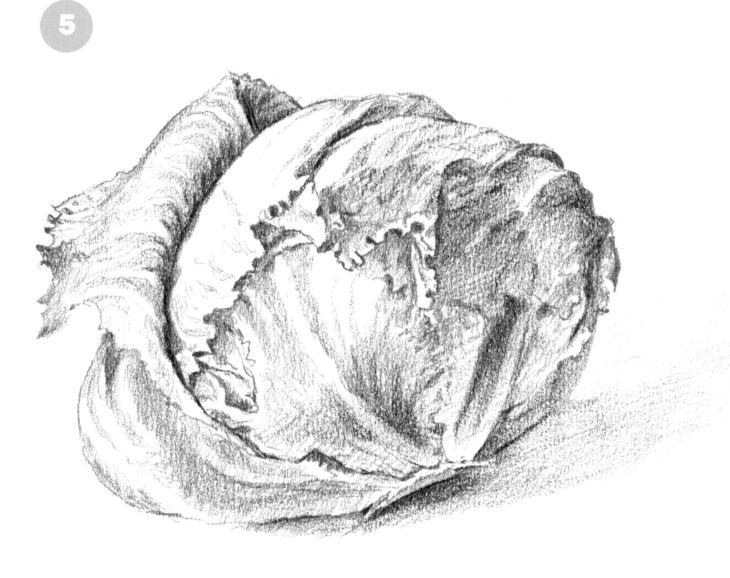

Now put in all the intermediate shades of tone to flesh out the form.
If you do this accurately enough it will make the cabbage look
convincingly three-dimensional.

 To convey the texture of the cabbage, note the difference between the curly, ragged edges of the leaves and the smoother, ridged curves of the main shape.

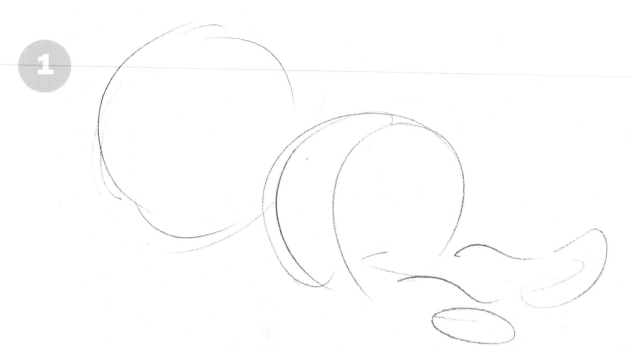

Start with a sketched outline to determine the shape and relative
size of each orange.

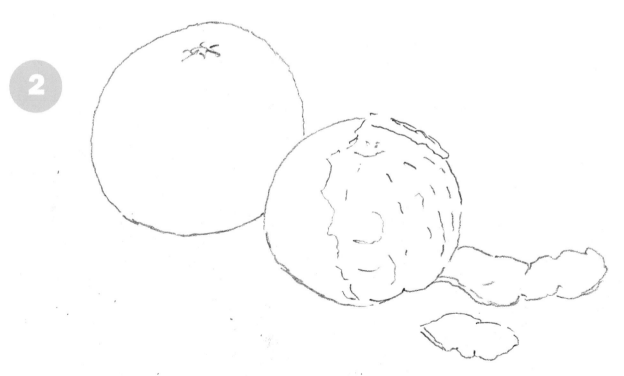

Then make a more careful drawing of the two oranges, especially the
outline of the peeled skin.

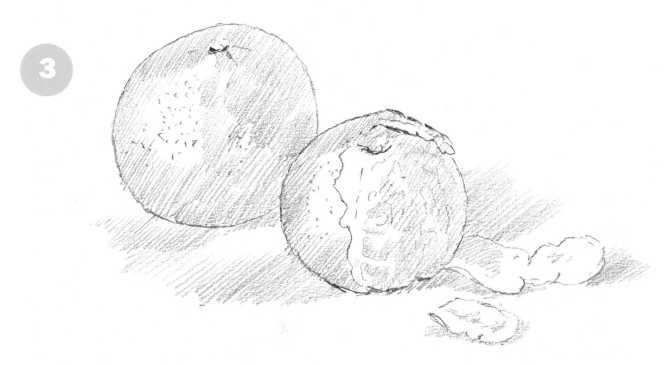

Now put in some light tone, using the hatching technique of drawing parallel lines, here drawn swiftly from upper right to lower left.

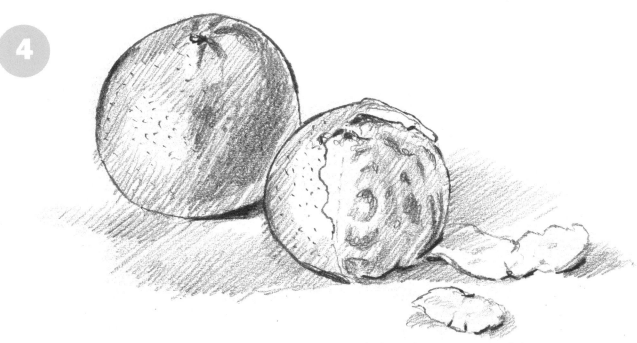

Next put in the darkest tones to help define the contours of the oranges and the uneven surface of the exposed flesh.

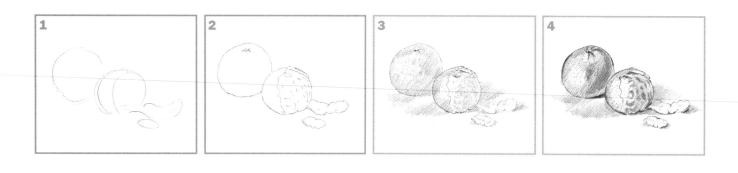

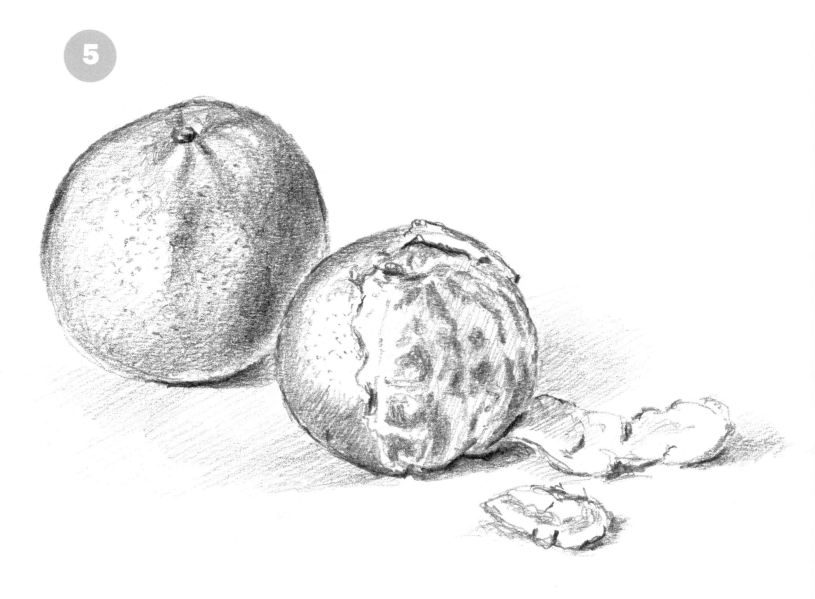

Finally, work over the whole drawing, putting in more subtle
intermediate tones.

 For a convincing drawing, make clear the difference in texture between the orange peel and the irregular surface of the flesh.

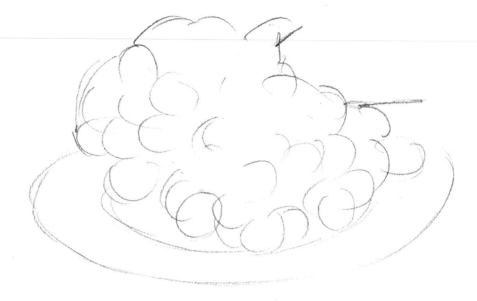

First make a loosely drawn outline to indicate the bunch of grapes and the plate it is on.

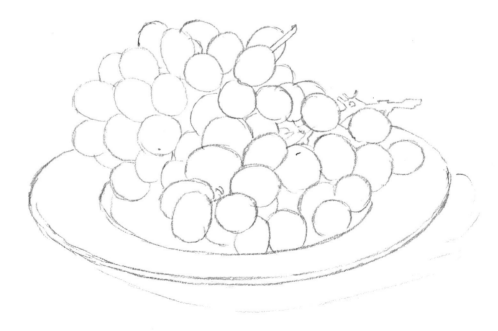

Now draw in all the outlines of the grapes, stalks, leaves and plate, being as precise as you can. Care taken now will pay off with the later stages of the drawing.

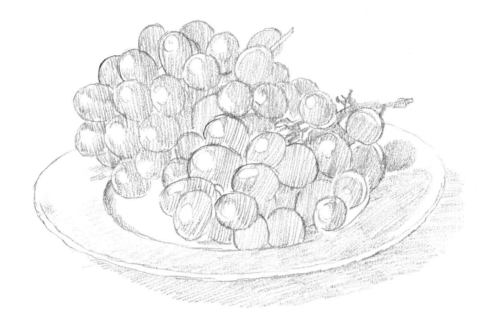

Next put in all the tonal areas, and as these are red grapes they will be mostly shaded with just a small spot of light on each one. Don't forget the cast shadow on the plate and tabletop.

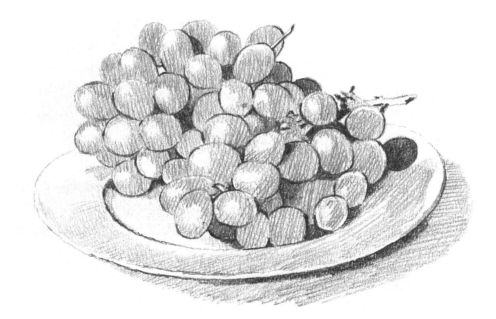

Now put in the very darkest tones seen on the objects, so that they are well defined.

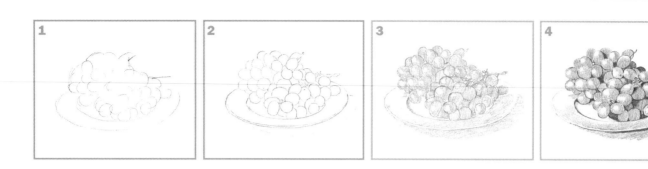

5

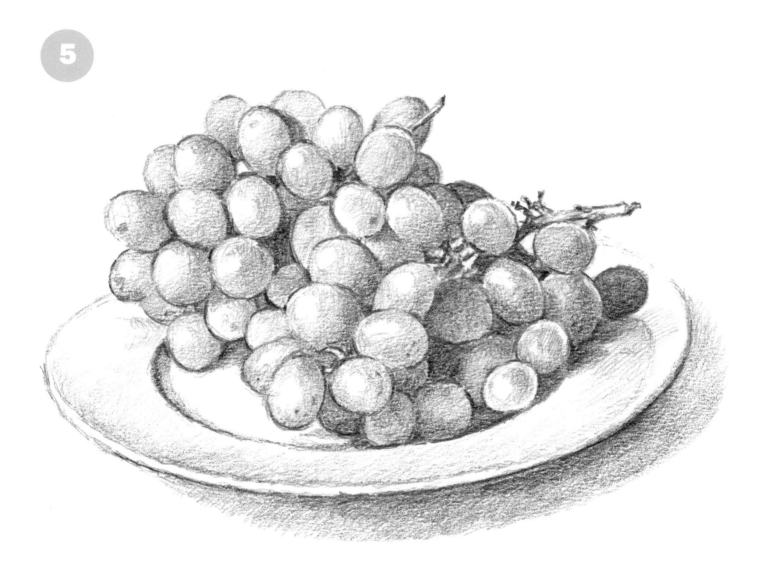

Last of all blend any darks and lights with mid-tones where needed,
until you are satisfied that the picture looks convincingly like the
rounded forms of the grapes and the flat plate.

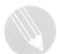 The grapes are all very similar, so once you get the hang of where the
light falls on the rounded surface you should be able to draw
in the tone quite rapidly. Remember that the ones in cast shadow
will be darker than the rest.

1

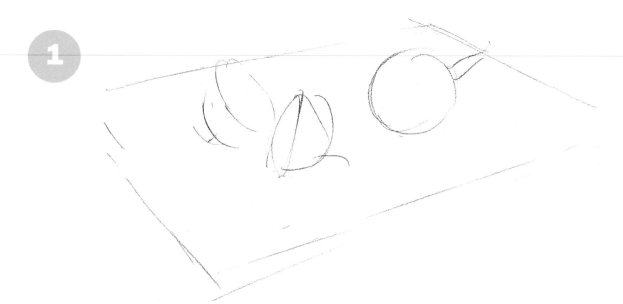

First make a loosely drawn outline to indicate the form of two onions, one cut in half, on a wooden chopping board.

2

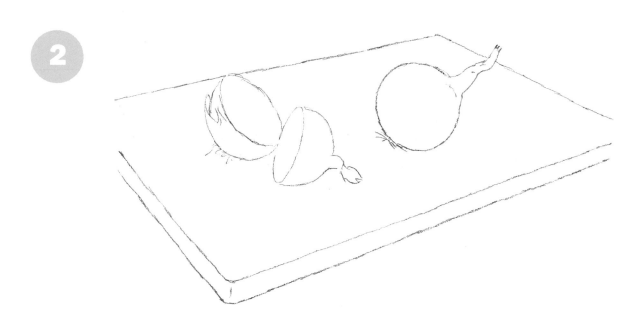

Once you are satisfied that the outlines of the onions and the board are correct, draw them in more carefully and precisely.

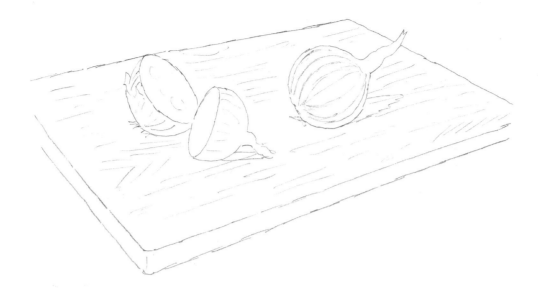

Next draw in the texture and tone of the objects, including the
texture on the onion skins and the grain on the board.

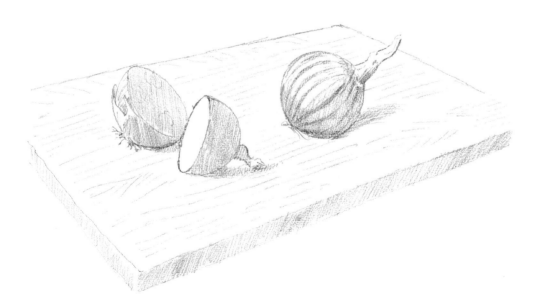

Put in the darker tones on the onions, the sides of the board and the
cast shadows to the right of the onions.

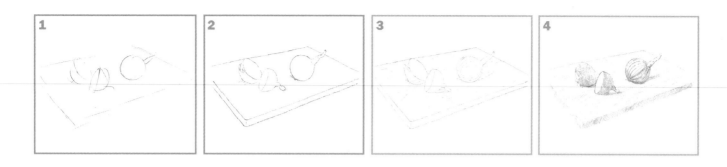

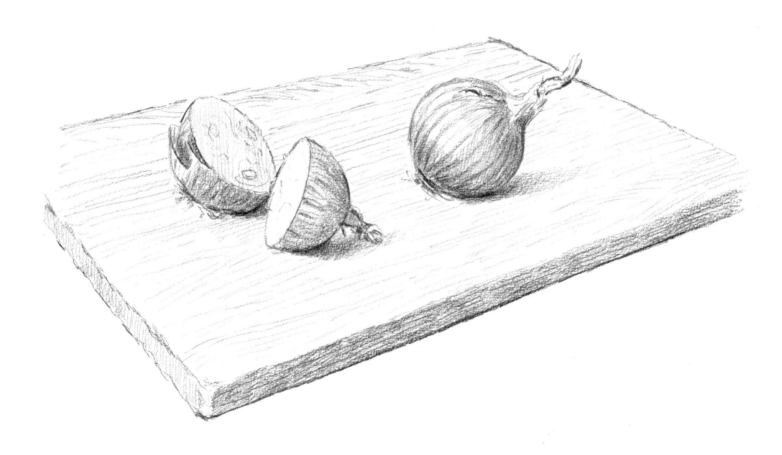

Now fill in all the mid-tones so that the transition from the light to dark tones looks more natural, giving a feeling of solidity.

 In this drawing, the patterns on the skins of the onions and the
surface of the board help to define their shapes.

A PINEAPPLE

1

To start with, make a loosely drawn outline of the whole fruit, including the leaves at the top.

2

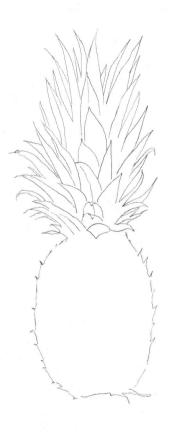

Draw in the outlines of the leaves in more detail and indicate the skin texture visible on the outer sides of the pineapple.

32

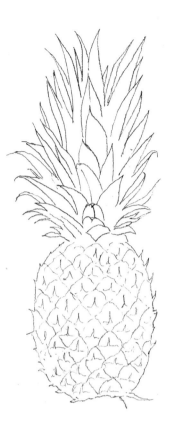

Now put in the shapes and texture of the characteristic marking of the pineapple skin.

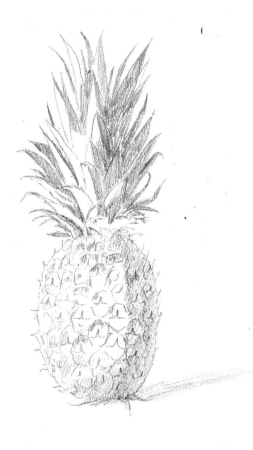

Put in the dark tones on the leaves, the shadowed side of the pineapple and the contoured skin. Add a cast shadow on the surface the pineapple is resting on.

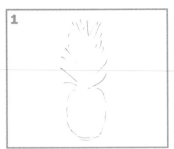
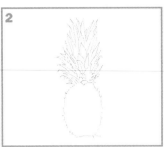
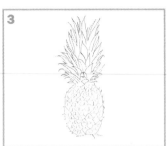
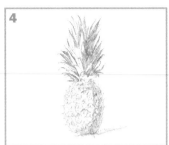

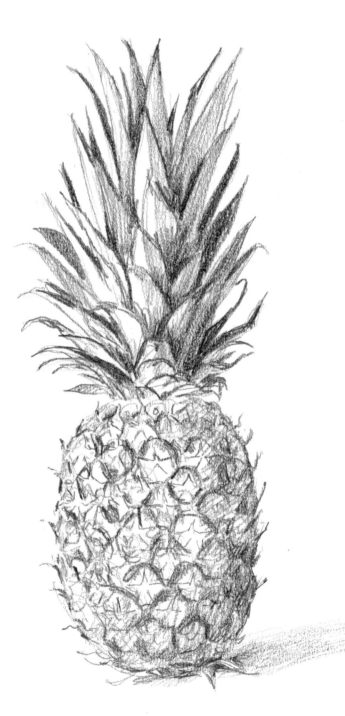

To finish the drawing, graduate all the tones so there is a smooth progression from the darkest to the lightest.

 In this drawing the texture of the fruit is very important, because the heavily patterned skin gives the characteristic appearance we expect from a pineapple.

TWO APPLES

1

First make a quick sketch to establish the difference in shape and size of the apples, paying attention to their angle and spacing.

2

Next make a more carefully drawn outline, being as accurate as possible, and indicate where the lighter areas of tone are.

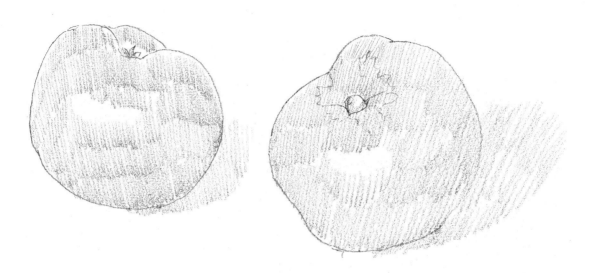

Now put in a light tone over all the areas that are not highlighted.
Because of the nature of the apples' skin, these are only minimal.
Add the cast shadows.

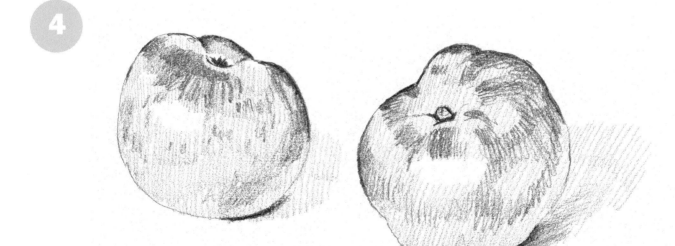

The next step is to put in the very darkest tones. These are mainly at
the top rear edges of the apples and also beneath them, in the
cast shadows.

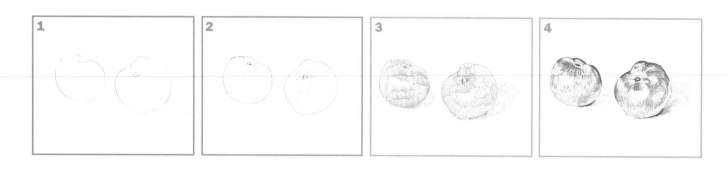

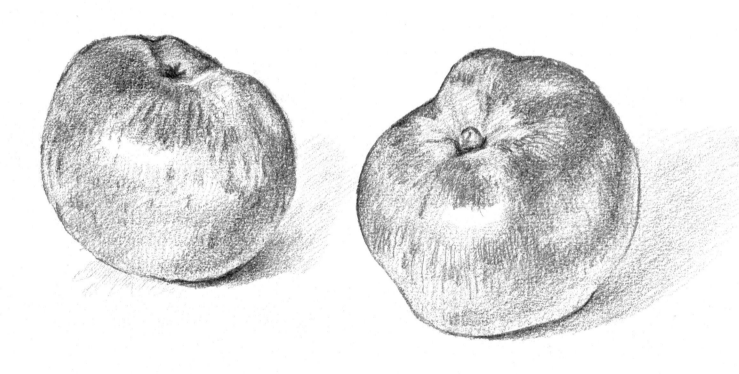

Now blend and work over all the areas to give a three-dimensional effect to the apples. Don't forget to blend the cast shadows – they become paler the further away they are from the apples.

 Notice the difference in shape of these rather irregular apples. Portraying this will help to give them their individual qualities and make the drawing more interesting.

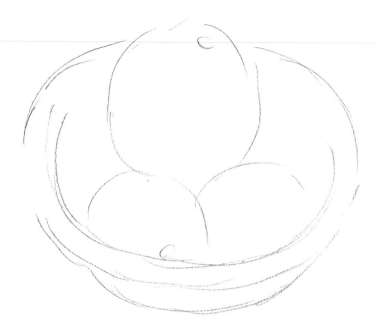

Draw a quick, loose line drawing to get a general feel for the main shape of the bowl with the fruit in it. Erase and correct anything that does not look right at this stage.

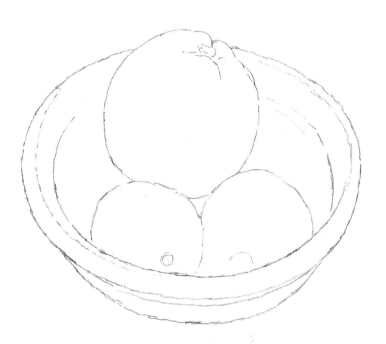

Now draw a more careful outline of the three pieces of fruit and the bowl holding them. Because the angle of view is high, little of the outer side of the bowl is visible; the focus is on the interior of the bowl and the fruit.

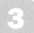

Put in all the areas of shade, but in a very light uniform tone as yet.
Leave all the highlighted areas untouched.

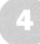

Now block in the darkest tones that you can see quite heavily, taking
care not to darken mid-tones too.

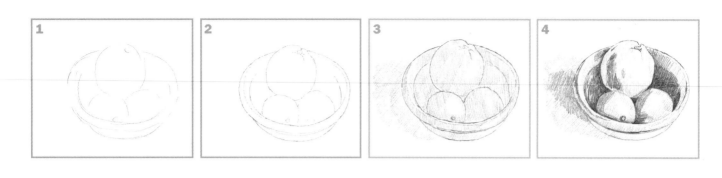

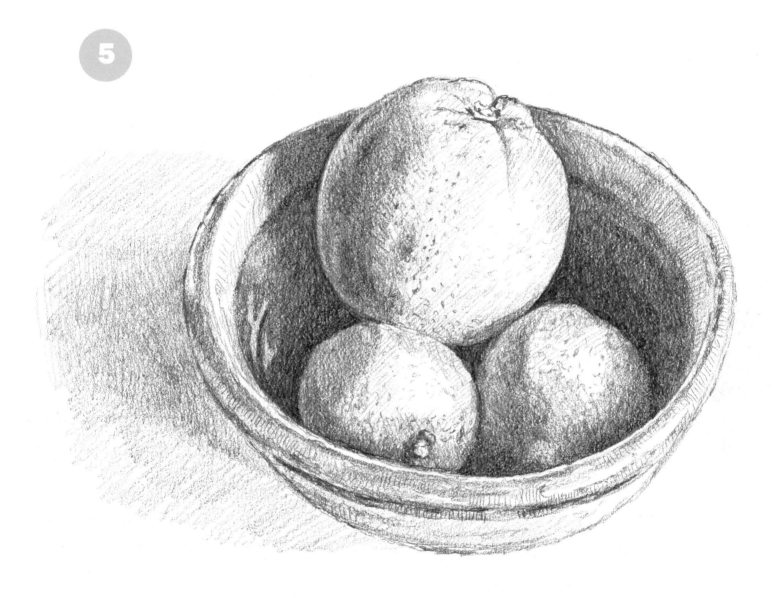

Finally, put in all the different areas of mid-tone with great care and attention to detail, blending them smoothly into adjacent lighter and darker tones.

 Because the bowl is relatively deep, the orange on the top catches much more light than the lemons underneath. Take care to show this in your use of tone.

1

Draw a rough outline of the shape of the bowl. Putting in vertical and horizontal lines will help you to get the ellipse (flattened circle) correct. In an ellipse, each quarter is the same as every other quarter, merely reversed mirrorwise.

2

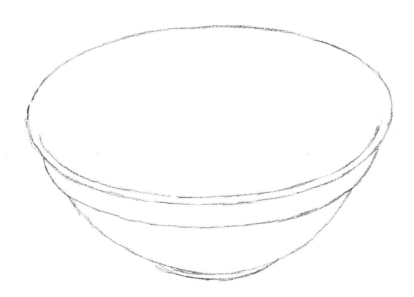

Now draw a carefully defined outline. Getting the ellipse and shape of the bowl is quite a challenge, and you might have to spend quite a bit of time getting the shape as correct as you can.

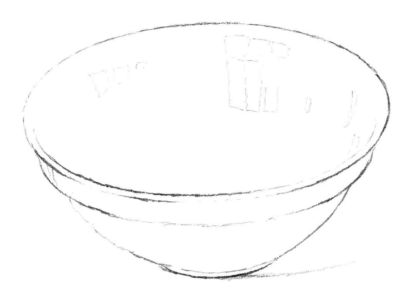

Now put in light outlines of all the areas of highlight you can see and strengthen the tones round the top and bottom edges.

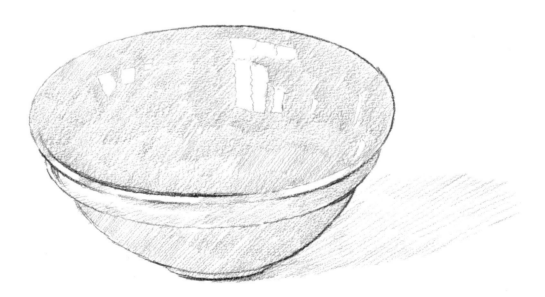

Next put a uniform light tone over all the areas that seem to have some shade on them, including the table with its cast shadow.

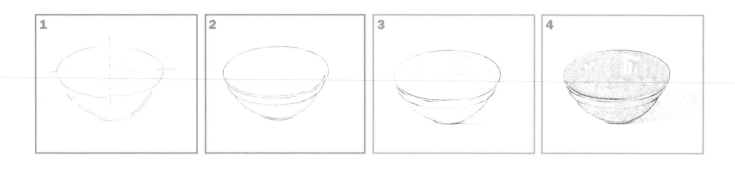

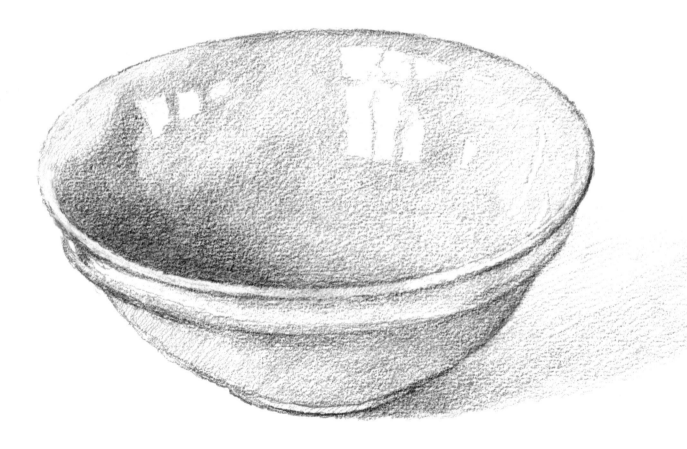

Lastly work up the darker and lighter tones until you are satisfied with the effect. The shape of the highlights tells the viewer that this bowl has quite a reflective surface.

A bowl such as this is always interesting to draw because making
the difference between the inner and outer surfaces clear is key to
whether the drawing works or not. The reflections and shading on
the interior are very important here.

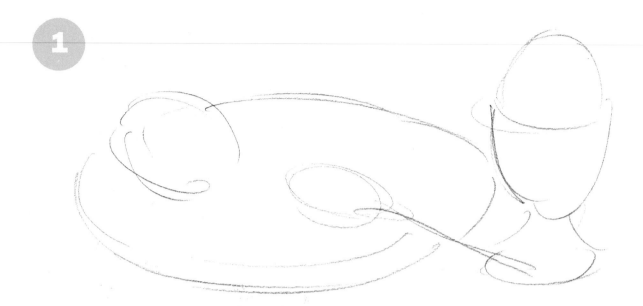

Start with a sketch that shows the size and position of each object. The upright shape of the egg in its cup provides a contrasting vertical to the nearly flat surface of the plate.

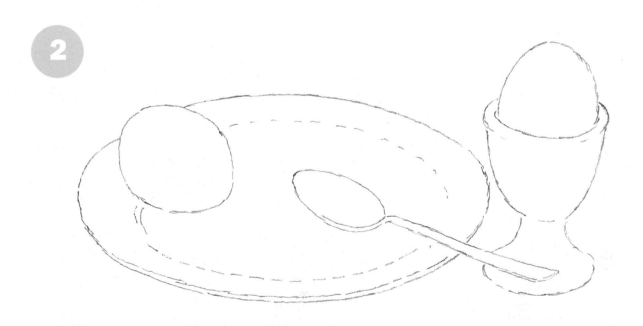

Now draw in the outlines carefully. The placing of the second egg and the spoon cutting across the edge of the plate and egg cup can be useful markers that will tell you if your overall shapes are correct.

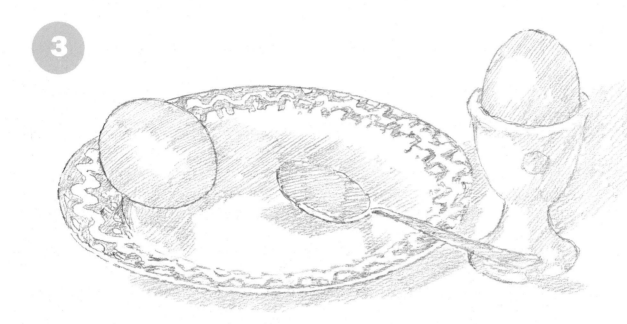

Now put in the tonal shading over the whole picture, using a light uniform tone and taking care to reserve the highlights. Indicate the pattern on the plate and the cast shadow.

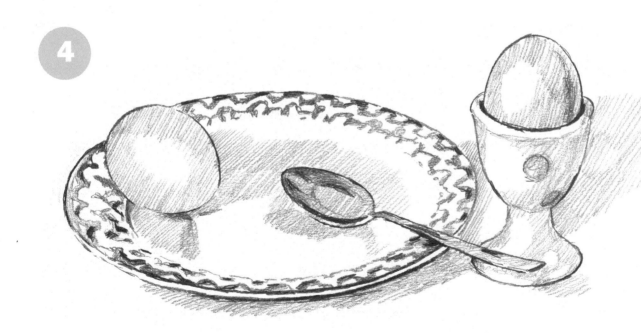

Mark in the very darkest tones. These are mainly to be found in the shaded area where the egg is surrounded by the cup, the lower edges of the cup, the edge of the plate and the bowl of the spoon.

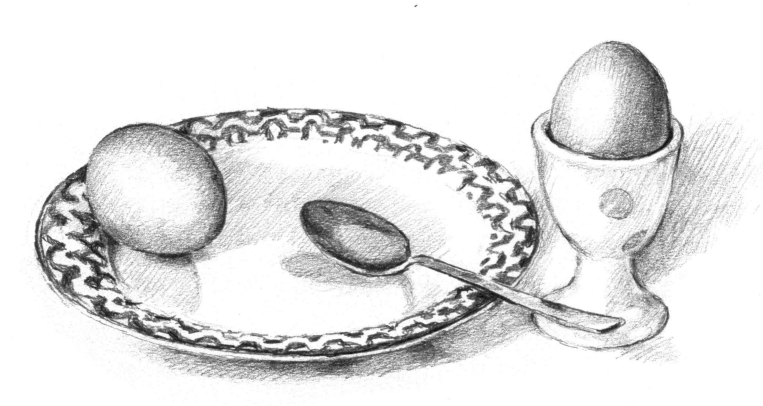

Now work over the whole composition, putting in the mid-tones to make the objects look more realistic.

 This composition is a study in ellipses and oval shapes. Take as much time as you need to get them as accurate as you can, since this will increase your dexterity.

1

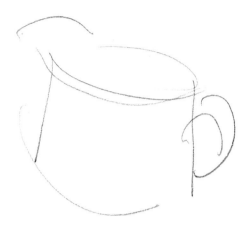

Draw in the main shape loosely and lightly. Make any necessary corrections at this stage until you feel you have got the overall shape of the gravy boat and its handle right.

2

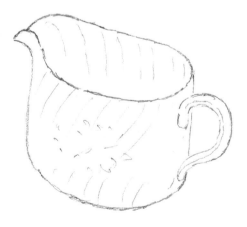

Now you can put in the firm outline shape of the gravy boat, including the marks to indicate the ridges in the china.

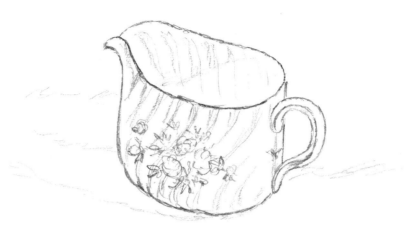

Put in the outline of the shadows on the surface and the pattern of flowers on the side.

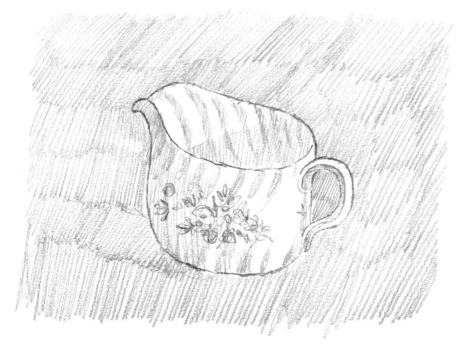

Now build up the shaded areas, all in a light tone, leaving only the brightest parts untouched.

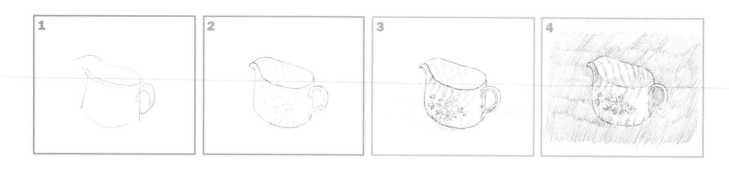

5

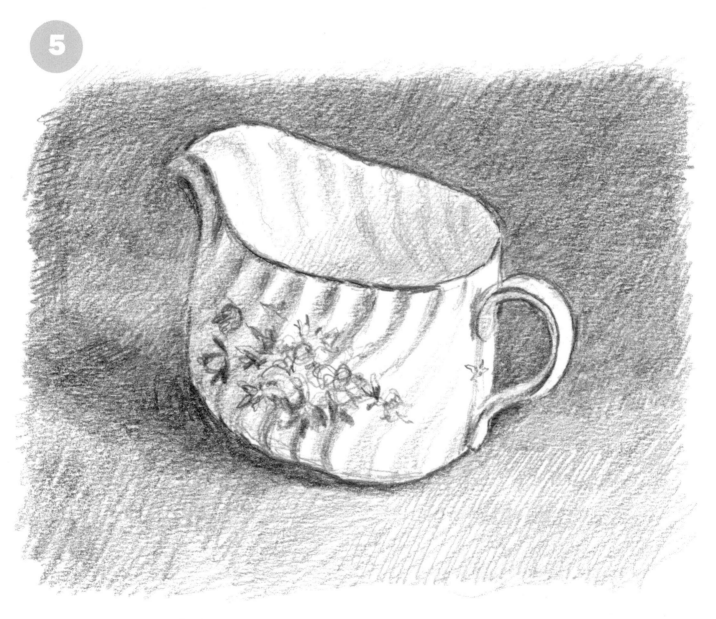

Last of all put in the darker tones, blending them into the lighter areas where necessary. The gravy boat is rather light in tone, which can be emphasized by increasing the darkness of the background.

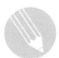 Using a dark background for a light-coloured object can help to give convincing depth to the composition. Put it in with multiple cross-hatching marks in any direction, allowing them to merge.

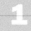

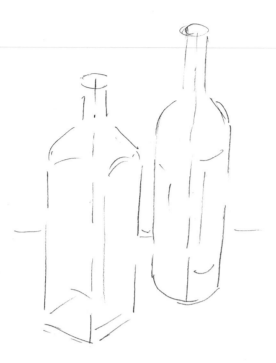

Mark the basic shapes of the two bottles in a faint outline. If it helps, draw a central line so that you can balance out the two sides of the bottles more easily. You can erase this later.

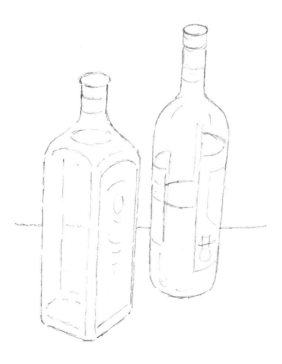

Now make a firm outline of the bottles' shapes, their labels and tops, and the edge of the surface they are on behind them. Don't be afraid to erase and correct as much as you need to at this stage.

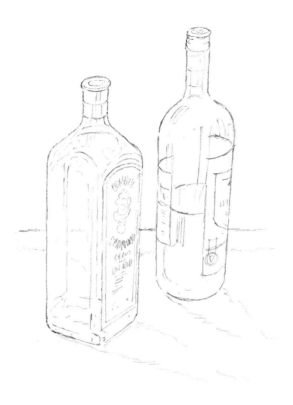

The next step is to carefully indicate the marks on the labels and the outline of the highlights and shadows on the bottles and the tabletop.

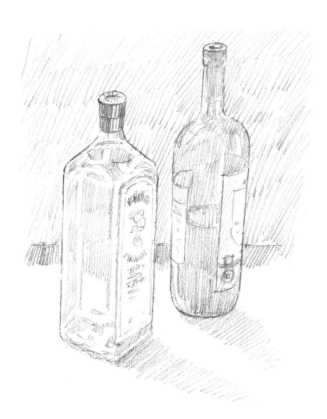

Then put in all the shading you can see, but very lightly marked. The dark colours of the bottles can be indicated in the same way. Leave the white paper showing through where the highlights on the bottles are brightest.

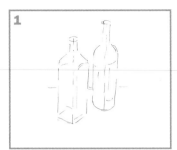
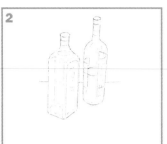
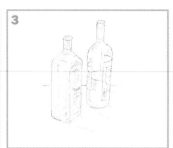
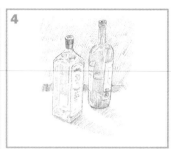

Now work over the bottles carefully, building up the dark tones
and blending them where they appear to be so. Don't forget the cast
shadows on the table.

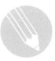 When you draw the labels on the bottles, don't try to reproduce every detail since if you do that they will distract the viewer's attention from the pleasing shape and texture of the bottles.

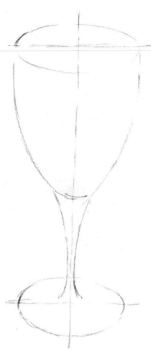

With the aid of centre lines for the whole glass and the axis of the ellipse for the top, lightly draw in the main shape as you see it.

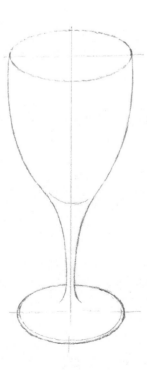

Now, with more care and focused attention, draw an accurate outline of the main shape of the glass.

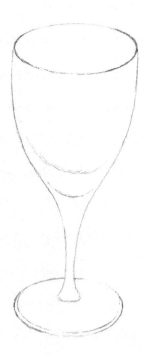

Erase the central and axis lines and draw in the shape
more definitely. Use your rubber to lighten some areas of the outline,
closely observing what you see in front of you.

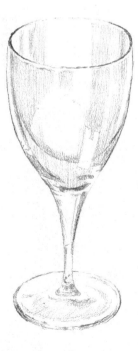

Next, very carefully and not too strongly, put in the areas of tone,
reserving white paper for the highlights.

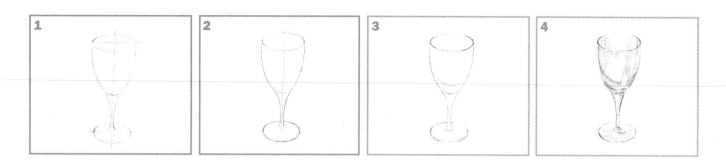

Finally, work over the tones until you have the darkest and lightest
carefully blended with mid-tones.

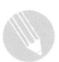 When you are drawing glass objects, put in as little shading as possible so that the final picture doesn't become too dark, thus losing the effect of transparency.

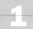

1

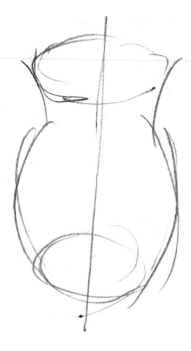

Loosely draw the main rounded shape, putting in a central line to help you balance the sides. Concentrate on getting the ellipse at the top and bottom right – this is the hardest bit.

2

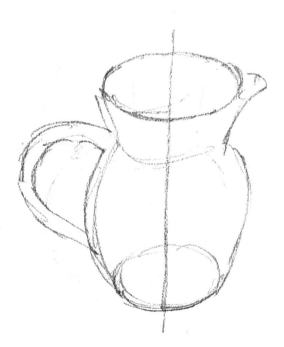

The next step is to define more accurately the main outline shape of the jug. Put in the handle, trying to get this outline as accurate and simple as possible. Make sure all the proportions are correct.

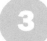

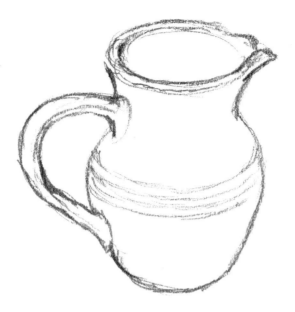

Refine the final outline, taking your time to convey the rounded, sturdy shape. Correct any line that is not true before you begin putting in the tone.

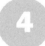

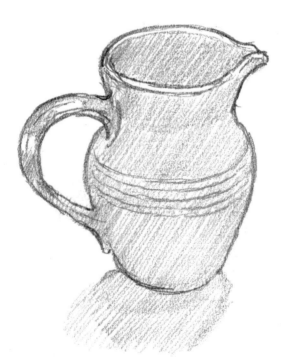

Put in the same tone all over the jug, except where there are highlights. This jug is seen against the light, so most of it is in shadow and the cast shadow is towards the viewer.

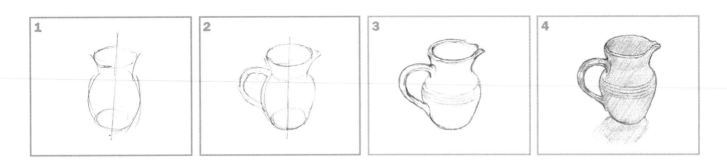

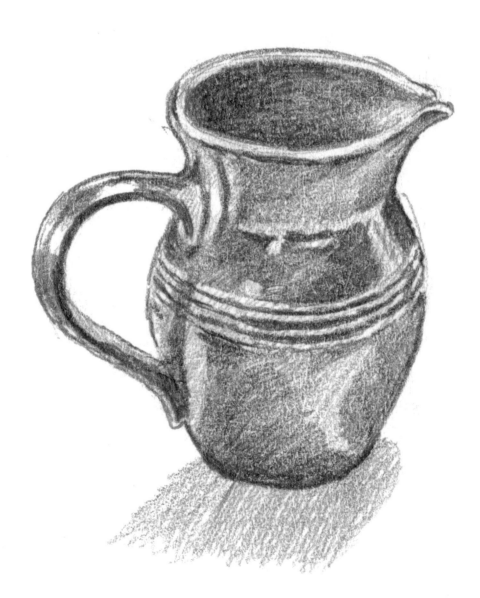

Build up the shading by increasing the darker areas such as the interior and making sure the reflections are in the correct tones, from very light to very dark.

 To draw your version of this jug you can follow my sketches or use a jug of your own. Try to make it look as convincing.

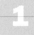

1

First sketch in the main dimensions of the objects and their relative positions to each other. The main thing here is to get the size right and the spaces between as you see them.

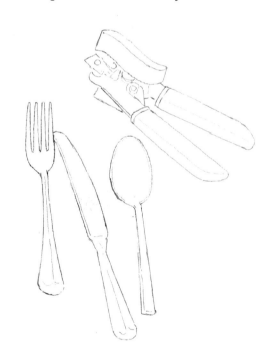

2

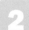

Now, with a more accurate line, draw in the exact shapes of the cutlery and can opener.

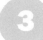

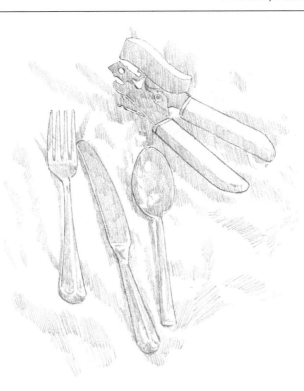

Next, put in the main areas of tone, all in the same strength. Don't forget to leave any highlight areas on the shiny utensils. Add some tone to suggest they are resting on a cloth.

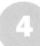

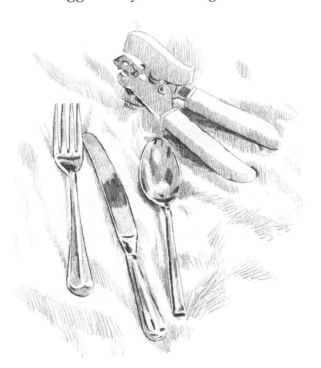

Now put in the very darkest areas of tone, blocking them in strongly. They derive from reflections on the surfaces and cast shadow from the can opener.

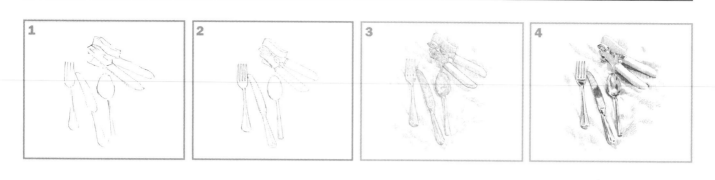

Finally, put in all the mid-tones that help to blend the darks and lights together. Take your time with this, as the more accurate you make it, the more convincing the result will be.

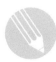

This is a good subject for practising your tonal skills and accuracy of
form; the drawing will only succeed if you convey the metallic
nature of the objects and their very familiar shapes.

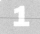

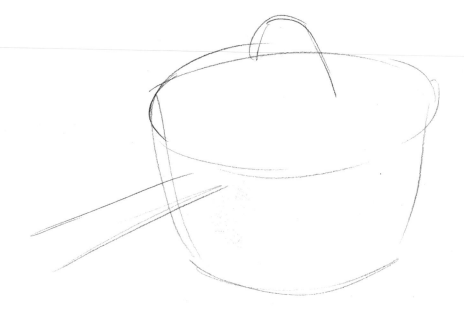

Loosely draw in the main shapes of the saucepan, including the handles of the lid and the pan itself.

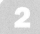

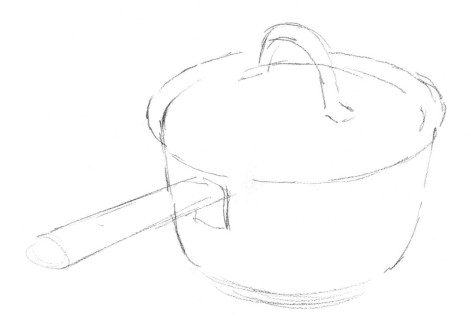

Now describe the form of the saucepan in greater detail. Take particular care with the angle of the handles.

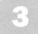

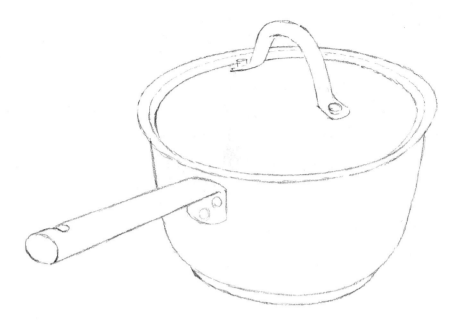

After any erasing that needs to be done, make the shape as accurate as is possible, in sharp outline. Note how the lip of the lid cannot be entirely seen on the near side.

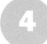

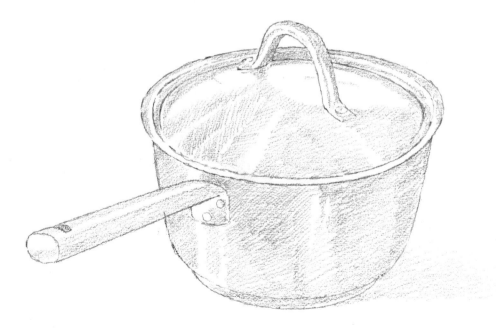

Next put a layer of the lightest tone all over the parts where the tones appear, leaving the highlights on the metallic surface untouched.

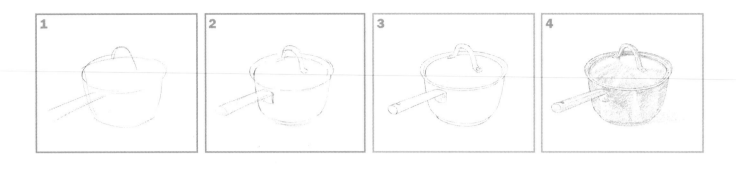

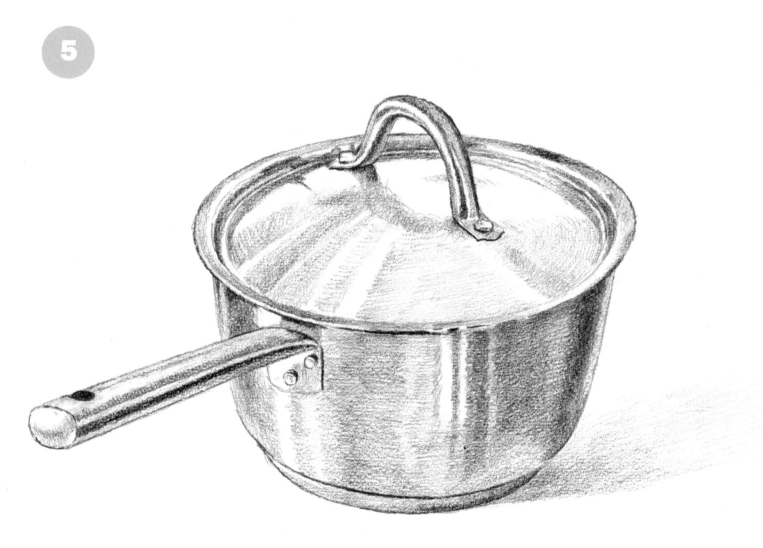

Finally, show how some tones are very dark and others are less so.
This will give the idea of the reflective qualities of the metal pan.

The reflections on metallic surfaces are always rather contrasty, so don't be afraid of making the darks very strong. In this example the texture of the metal creates a slight horizontal grain which you can indicate by the direction of your marks.

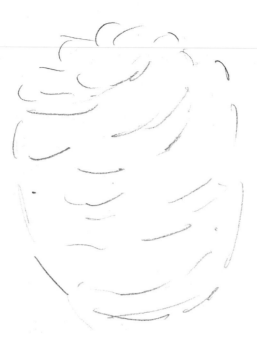

1

Draw in the main shape loosely, gaining an idea of the angles of the pine cone's sections.

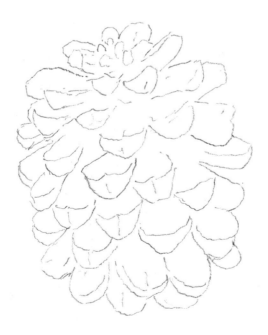

2

Define it next with a careful outline of all the parts, showing the blocky shapes of the opened scales of the cone.

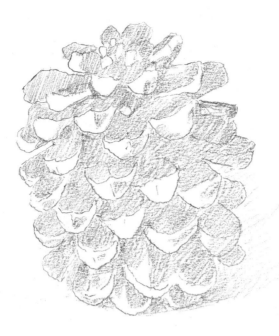

Put in the areas of shade lightly, all over the darker parts of the cone.
The highlighted areas are at the ends of the scales.

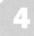

Mark in the darkest parts, noting how the deeper hollows in the
cone look much darker.

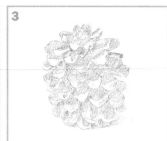
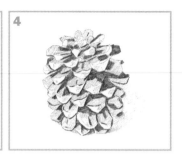

5

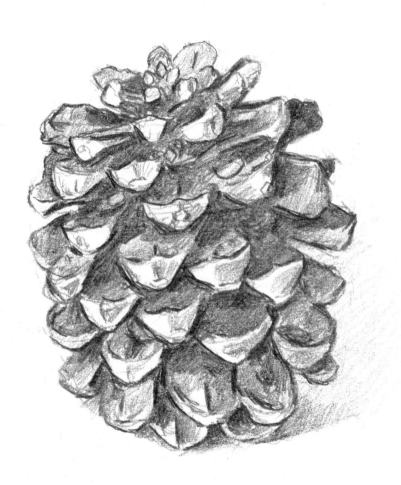

Blend the tones together until the cone starts to look solid and
structural, with its very matt surface.

The pine cone is an example of natural form that looks so well-
designed it seems as if it might almost have been made for your
interest. Drawing forms such as this makes you begin to realize the
essential creativity in nature.

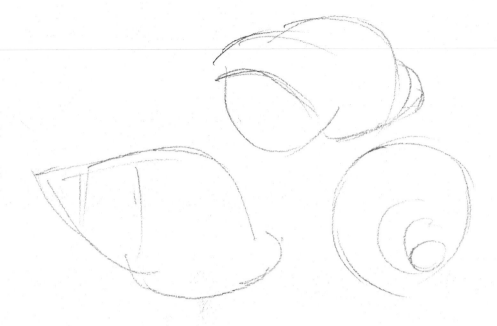

1

Sketch in the main outlines of the shells. As they have a similar shape, I have placed them at varying angles so that there is a different view of each one.

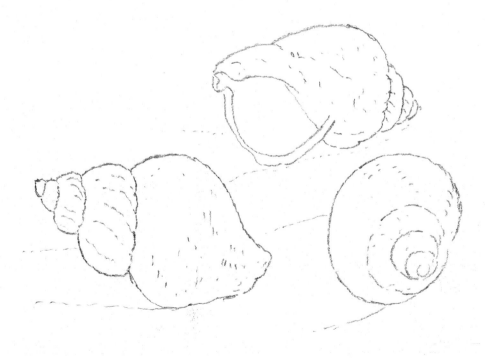

2

Draw them in more carefully next, getting the spiral form of the shells as accurate as possible.

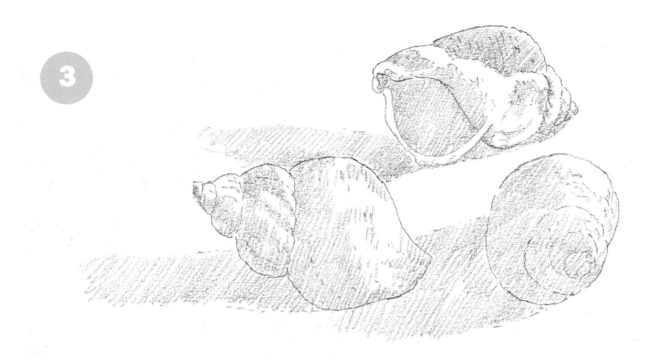

3

Put in light tone all over the shells apart from where highlights can be seen. Add cast shadows on the surface on which the shells rest.

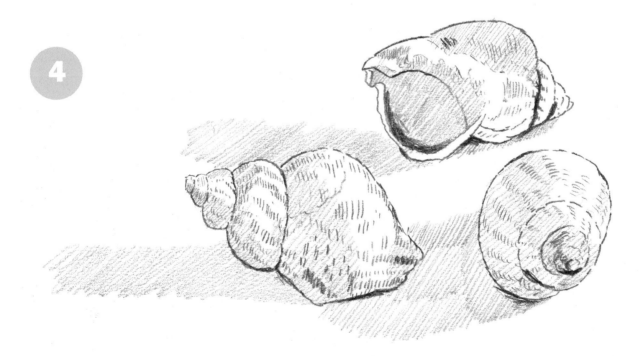

4

Mark in the darkest tones to define the shapes. Some of these tones will emphasize the texture of the spiral patterns running across the surface of the shells.

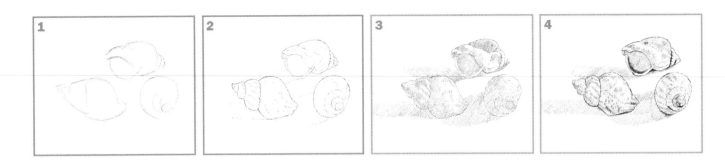

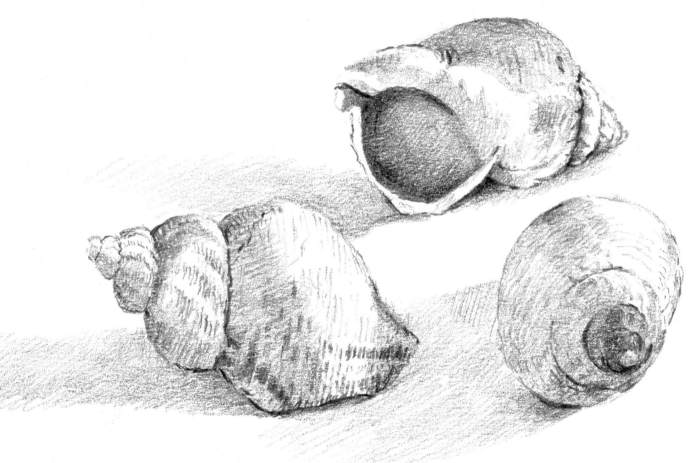

Now work over the whole picture, adding the mid-tones and blending them in until the shells have substance and look convincingly three-dimensional.

 Objects such as these are subtle in their shapes and textures and it is worth spending some time building up the qualities you can see in them. Avoid overemphasizing any of the edges as you will risk losing their appearance of fragility.

A VASE OF FLOWERS

1

Loosely sketch the main shape of the vase and flowers, using shorter, more diffuse marks for the latter.

2

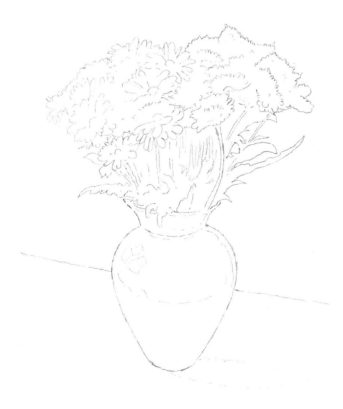

Next draw everything in a more defined outline, so that you are sure that the shapes of the flowers and the vase are pretty accurate. Lightly outline the highlights and cast shadow.

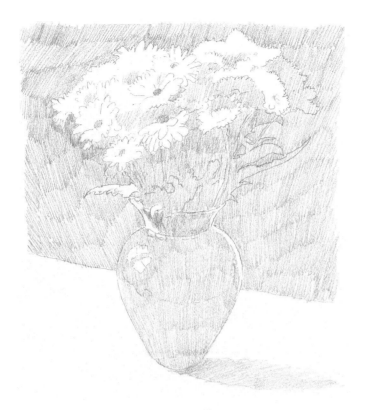

Now work over the whole
picture with a light,
uniform tone. Leave the
lightest areas on the vase,
table and flowers as
white paper.

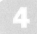

Now work over all the
areas where the shadow is
deepest, so that you have
all the very dark areas
marked in.

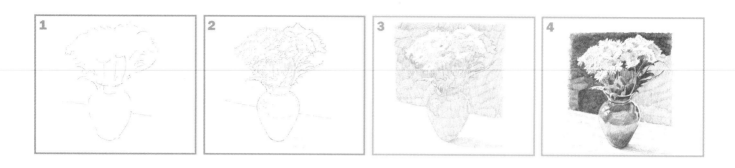

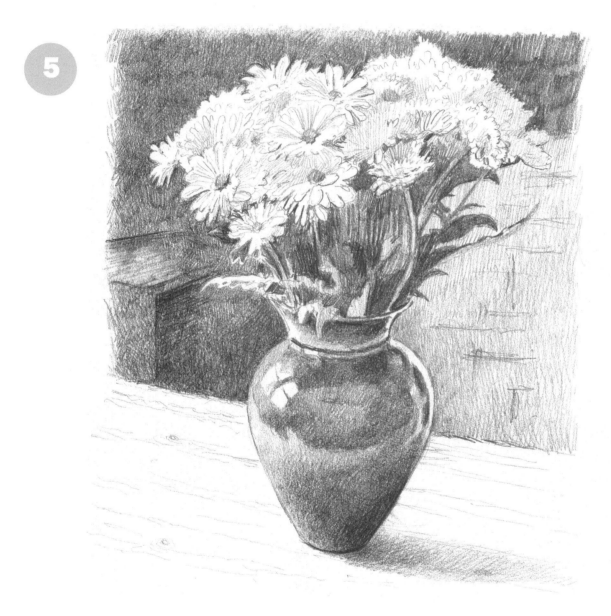

Working over the whole composition, blend in the darks and lights with mid-tones and put in any definition that is still needed. Take your time, since this is quite a complicated subject.

 Here the background is just as important as the vase of flowers; the contrasting textures emphasize the pale, bright flowers and the solidity of the vase, giving them more reality.

1

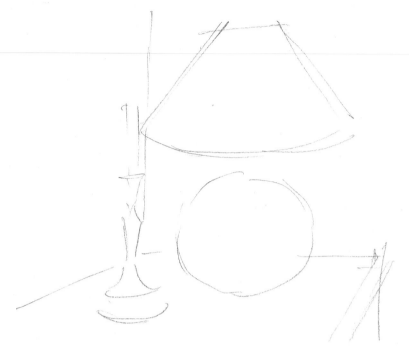

Draw very loose marks that give you some idea of the shapes and proportions of the two objects. The top of the cupboard they are on is seen in foreshortened perspective.

2

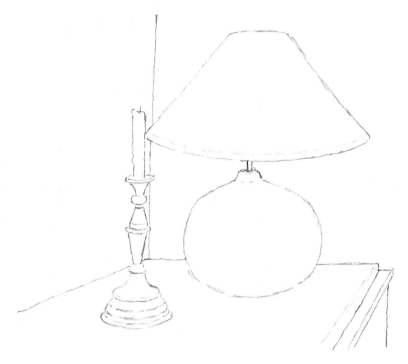

Now draw both objects and the cupboard top more carefully in a clearly defined line that gives you all the main shapes.

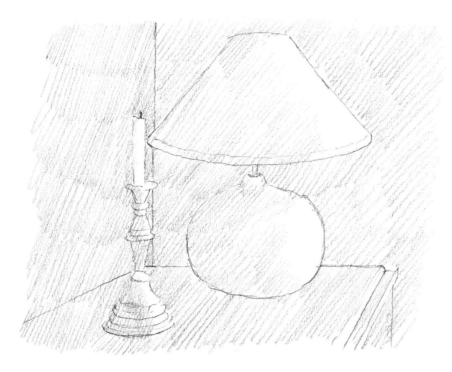

Put in a uniform light tone where shade appears to fall on the objects, cupboard and background, omitting only the highlights.

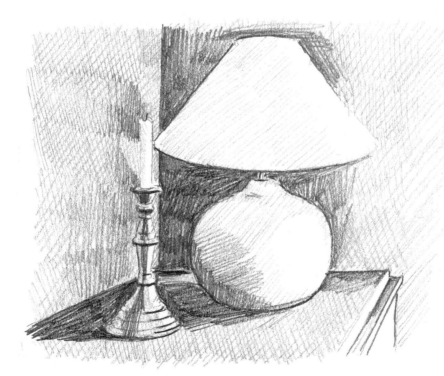

Now block in the darker parts of the composition more heavily. Notice how the highlight on the candlestick is helping to create an impression of bright metal.

5

Then, with great care, blend the tones together until the transitions from light to dark are convincingly graduated.

The materials of all the parts of this composition are different and your textural shading should take this into consideration. The metal of the candlestick provides more contrast than the ceramic lamp base, which in turn has more contrast than the lampshade. The darkness of the smooth cupboard top and background wall helps to give an impression of depth in the picture.

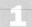

A CROWN

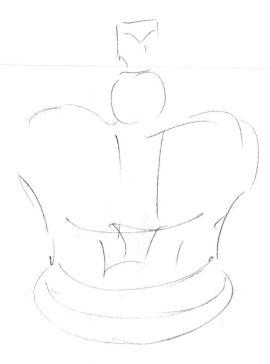

This example is rather special, in that most of us are not in possession of a crown to draw from life. However, it is not difficult to find a really good photograph of one. First make a general set of marks to indicate the size and shape that you are drawing.

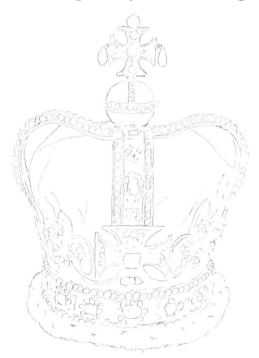

Then draw a more carefully judged outline, showing all the main details of the crown clearly.

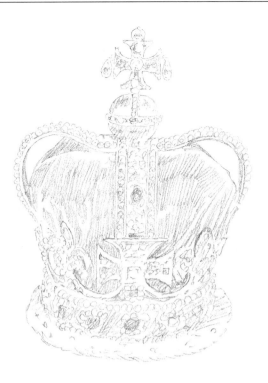

Next, using the lightest tone, shade in all the areas except the highlights. The all-over tone of the velvet will look darker than most of the metallic and jewelled parts.

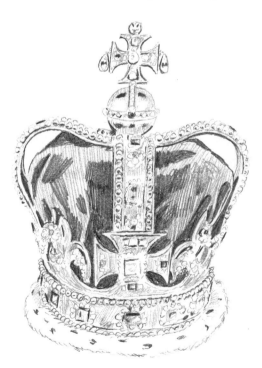

Now mark in more definitely the darkest tones that you can see. They are most apparent on the irregular surface of the velvet.

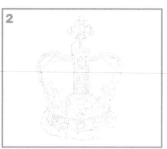

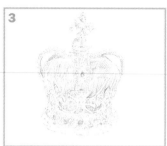

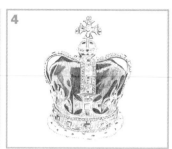

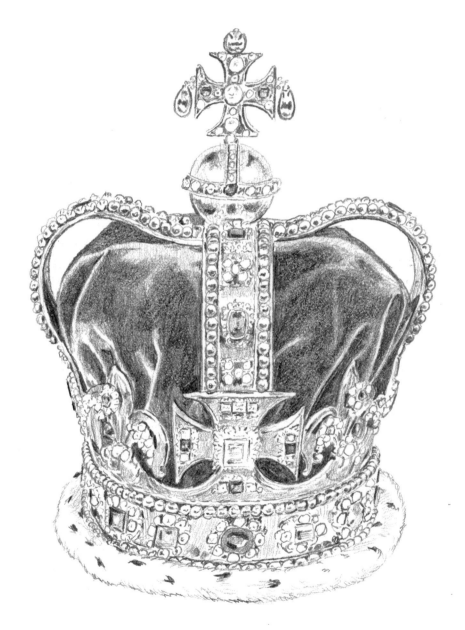

To finish the drawing, put in all the mid-tones, blend the marks for a
smooth effect and carefully delineate all the intricate details.

 As I drew this crown using a photograph for reference, I chose a very detailed and photographic effect. It is not an easy subject to tackle, but even if you are not entirely satisfied with your own work you will have improved your observational and drawing skills.

1

The aim of your initial drawing is to show the main areas of the two shoes and roughly indicate the laces.

2

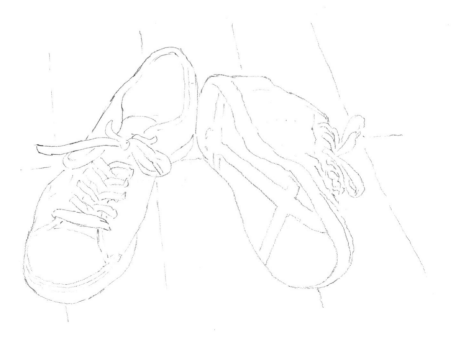

Then you will need to draw the shapes and details of the laces, rather more carefully. Begin to add the pattern on the visible sole and the floorboards.

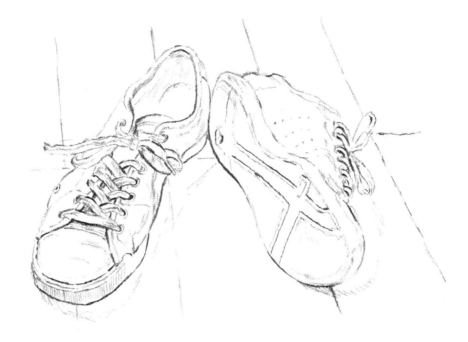

Next, put in more detail, including the very strongest lines that define the shape clearly. Begin to add indications of tone on the laces and shoes.

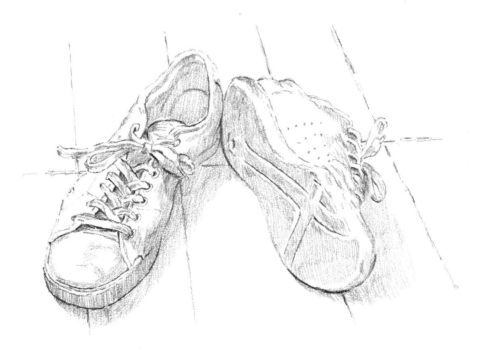

Put in uniform light tone over the shoes, reserving white paper for highlights, and add the cast shadows on the floor.

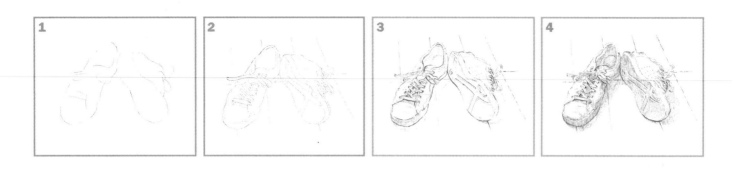

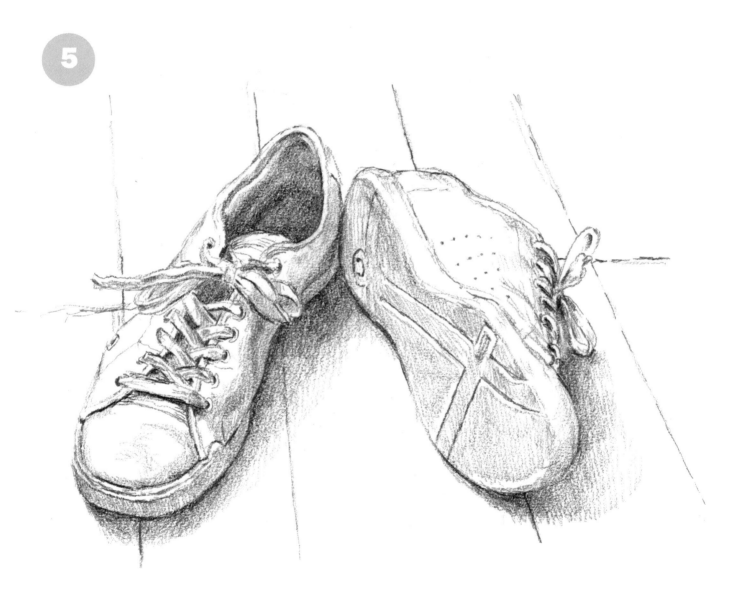

Add the very darkest tones inside the left-hand shoe and deepen
the cast shadows. To finish, blend in the tones by drawing in all the
medium-tone areas.

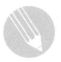 Ordinary objects that have seen a lot of use such as these running shoes are often interesting to draw in detail as you can show the wear and tear on them, giving character to the drawing.

A ROCKING CHAIR

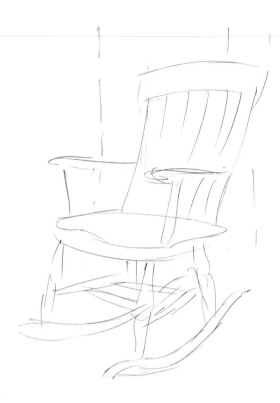

First draw a rough outline
of the whole rocking chair,
correcting your marks if
necessary until it looks the
right size and shape.

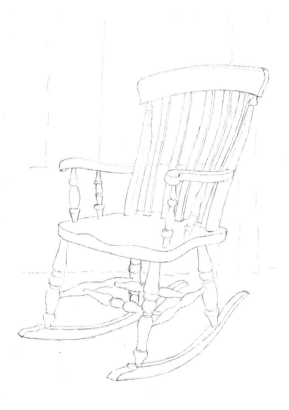

Now draw in all the parts of
the chair, taking great care
to get the shapes and
positions of the parts in
correct relation to each
other. This may take some
time, as there are many
subtle relationships
between them.

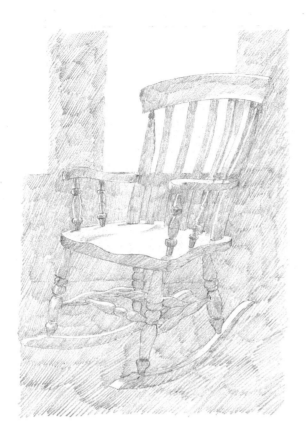

Next, start to show where the main areas of shadow appear, using a very light tone. Notice how the position of the light source (a window) affects where the shadows and highlights fall.

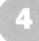

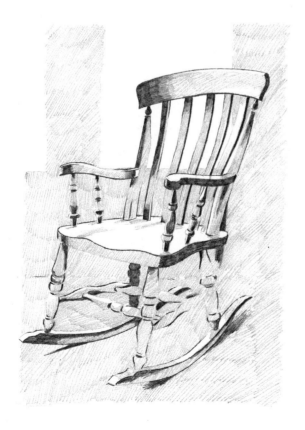

Put in the very darkest tones. Some of these will be against the lighter background and others will be on the parts of the chair facing away from the light.

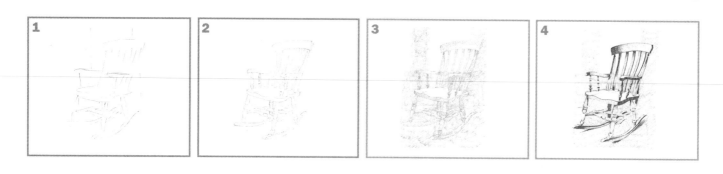

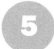

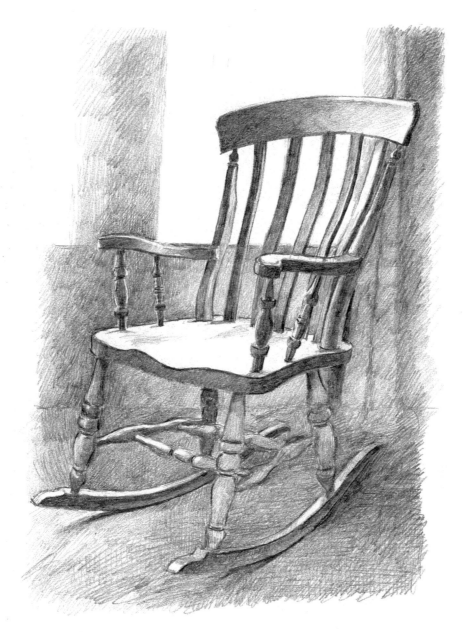

Put in all the mid-tones, blending the darkest towards the lightest.
Where there is maximum contrast, between the seat and the foremost
edge and arm of the chair, increase the intensity of the dark tone.

This is a complex and decorative object, and as long as you get the main shape accurate enough it will make an attractive drawing. Just be careful to record the tonal areas correctly, because this will give more solidity to the whole work.

A PAIR OF BOOTS

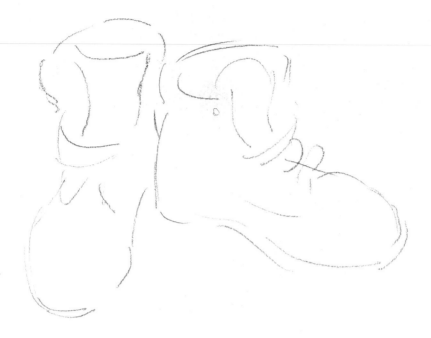

Sketch in the main shape loosely, taking care to draw what you really see rather than your preconceptions of what boots look like.

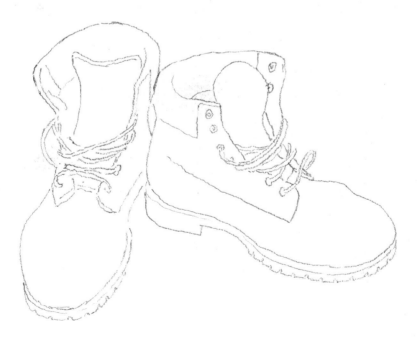

Now draw the outline more carefully and more definitely. It should be obvious from the irregular surface of the leather that these boots are not straight from the box.

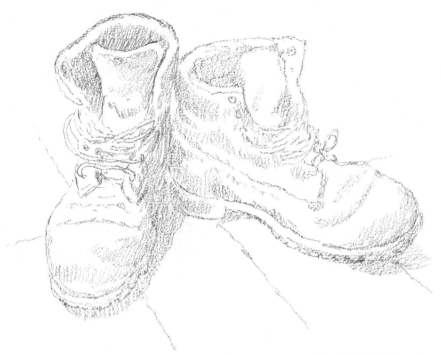

Then put in tone all over the boots except the highlighted areas,
using only a light tone.

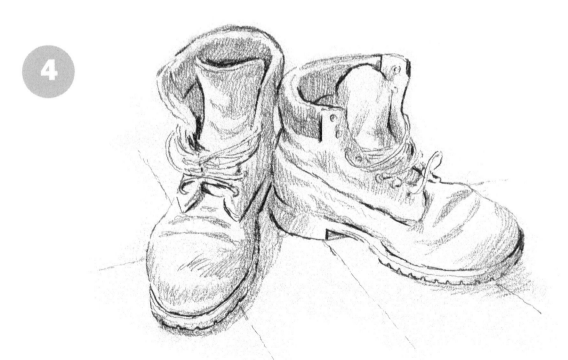

Next, put in the darkest tones to add to the definition – in this
drawing they are minimal and quite linear. Add some cast shadow.

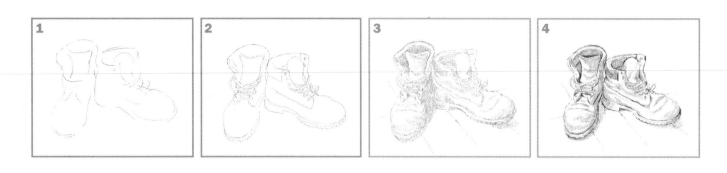

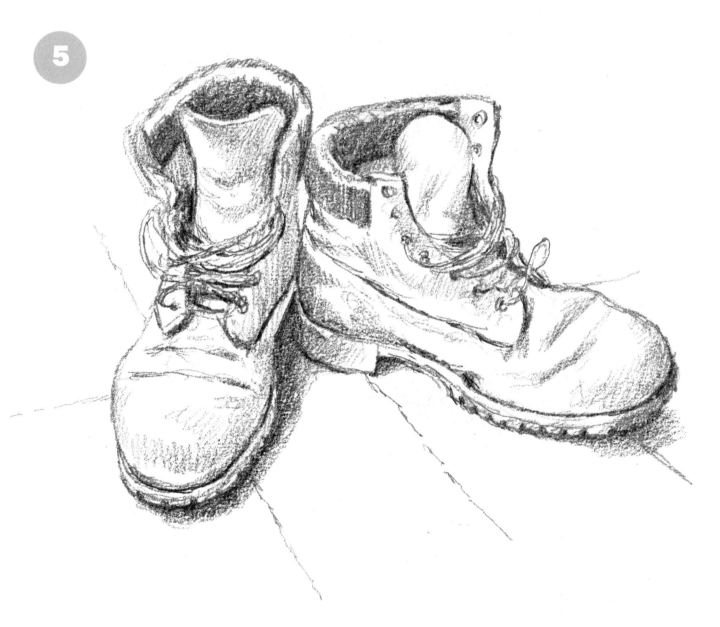

Finally, add the mid-tones and blend them in. Deepen the cast shadows and add lines to suggest floorboards, varying the width of them a little to make them look convincing.

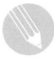 As with the running shoes on pp.96–9, the well-used look of the boots helps to define their characteristic qualities. Notice the relatively subtle difference between the left and right one. The lines of the floorboards help to suggest the weight and solidity of the boots.

A COAT ON A HOOK

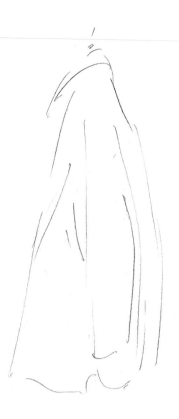

First make a rough sketch of
the overall shape of the coat
and the collar and sleeves.

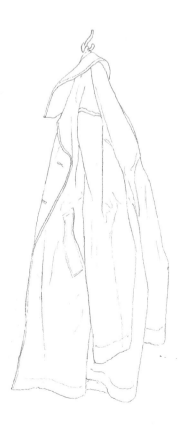

Now draw a more accurate
outline of the whole coat
and the hook it hangs from.
As it is bulky fabric there
will be few absolutely
straight lines.

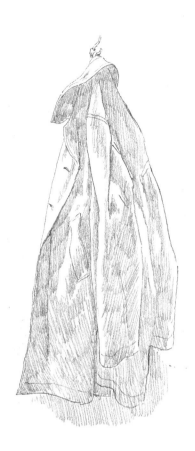

Put in the areas of tone, as yet quite lightly.

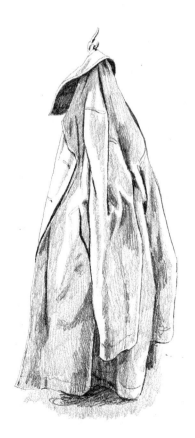

Mark in the darkest areas strongly. The deepest shadow of all is beneath the collar.

5

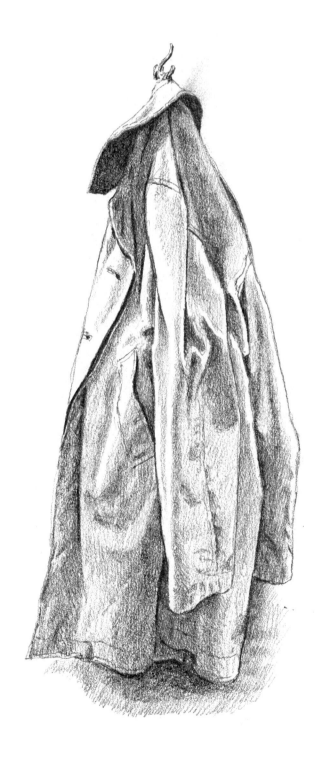

Work over the whole shape with tones that convey the feel of the material by darkening and lightening around its folds.

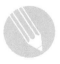

To make this drawing, really concentrate on showing the folds accurately so that the viewer will be convinced of the weight of material suitable for a coat.

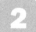

1

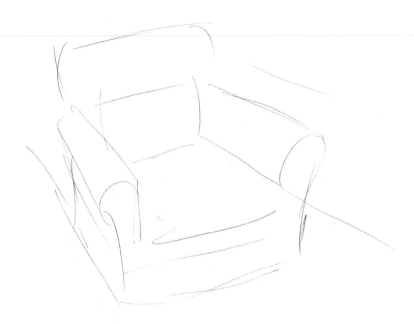

First draw a loose set of lines to give some feeling of the shape and proportion of the armchair. This should give you a basic area in which to construct your drawing.

2

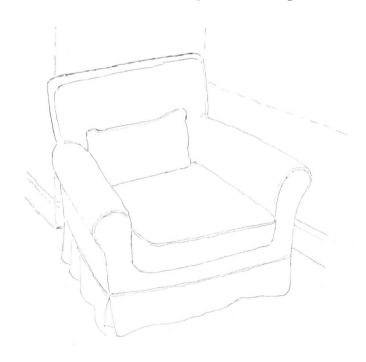

Next, working more carefully, draw a fairly accurate outline of the whole shape so that all the features of the armchair are firmly established.

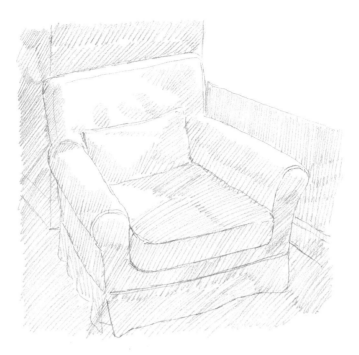

Block in the main areas of shadow, using as light a tone as possible.
All areas should be covered with the same strength of tone,
irrespective of how dark they really are.

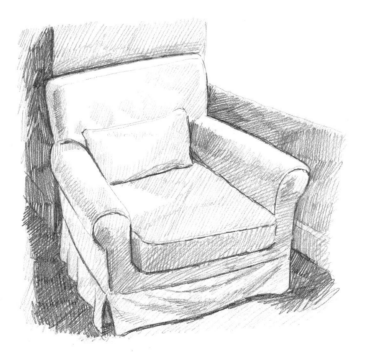

Now block in the main areas of very dark tone, not yet putting in any
of the in-between tones.

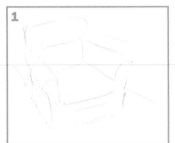
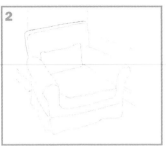
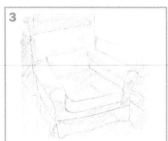
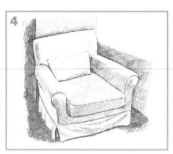

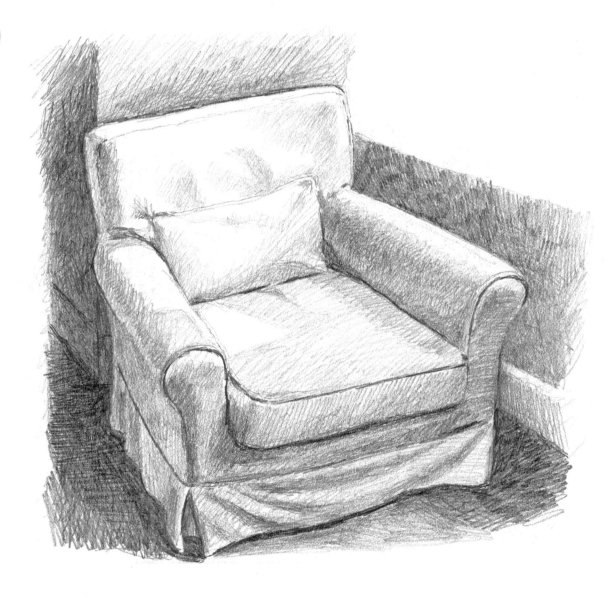

Last of all, build up the mid-tones, so that the subject matter starts to look convincingly three-dimensional. This can take rather longer than the earlier stages, as it is a more subtle exercise.

The contrast of the darker background against the armchair helps to convince the eye that the object is projecting in space. This is aided by the pale tone of the armchair, which is catching the light from a window beside it, while the surrounding area is mostly in shadow.

A FATHER AND DAUGHTER

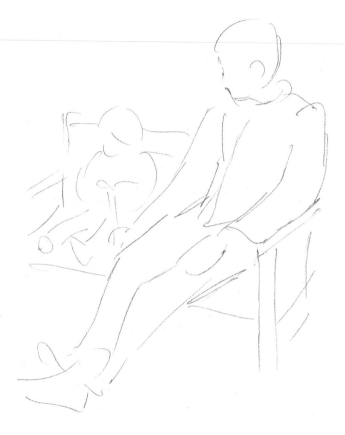

Sketch in the main shapes of the figures, correcting your marks as necessary until you feel that you have the right proportion of the two seated bodies.

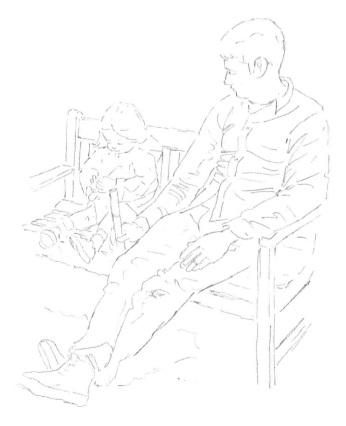

Now draw the whole composition with as much accuracy as you can manage – this subject is quite a challenge.

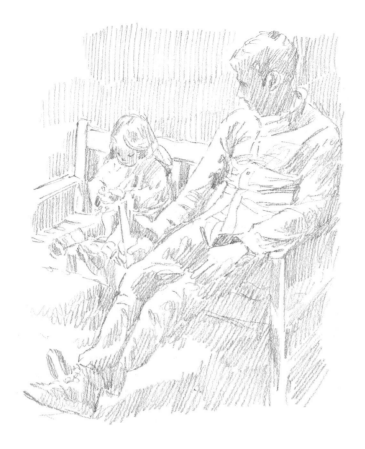

Now put in tones quite lightly all over the areas that have shade on them, leaving white paper where highlights occur.

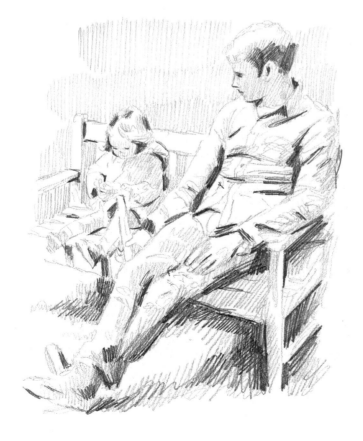

Next put in the darkest tones, quite heavily. As you can see, the picture starts to come to life now.

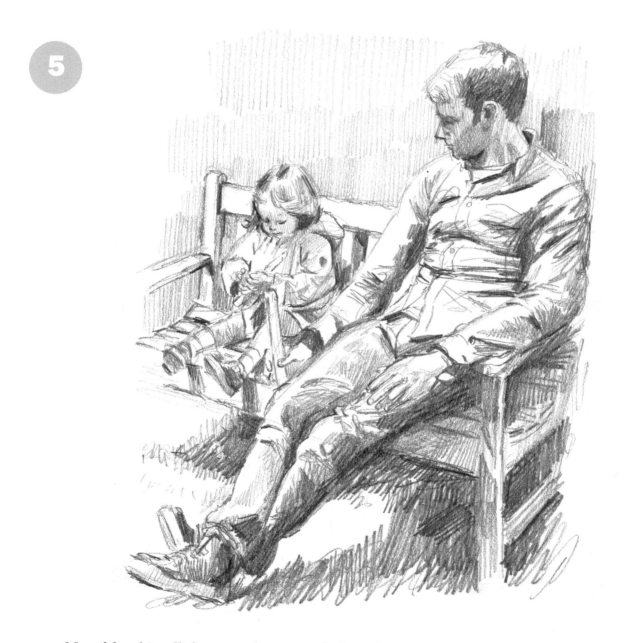

Next blend in all the tones between dark and light so that the picture gains a feeling of solidity. The extent to which you do this depends on whether you want a highly finished picture or a more loosely drawn effect – both can be successful.

 When you are drawing figures, the most important thing is to make
the person look natural rather than worrying about facial likeness.
The pose gives a lot of information to the viewer and the expression
on the face can be kept at its simplest.

A GIRL'S PORTRAIT

1

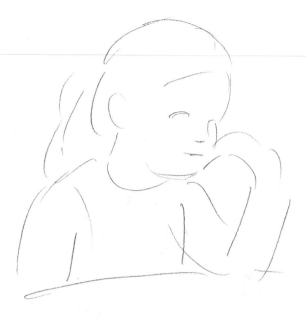

Make a quick sketch to gain a feel of the head and shoulders, taking a bit of care to get the angle of the head against the hand right.

2

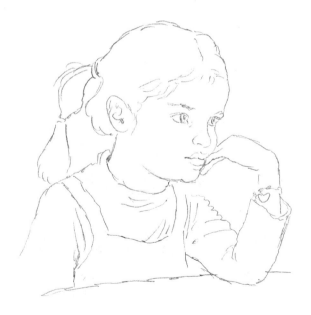

Now draw in the whole outline of the face, hair, hand and shoulders as accurately as you can.

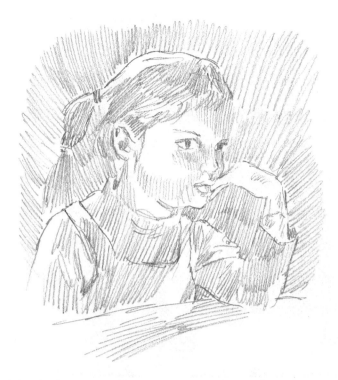

Now add a light tone all over areas where there is some shadow,
including the background.

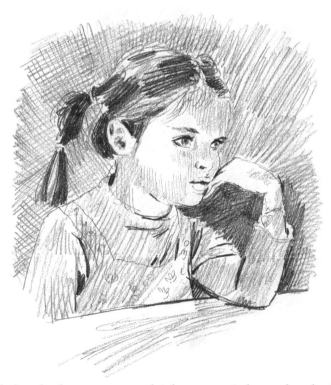

Now add the darkest tones, which are mainly on her hair and in the
shadow behind her arm but also occur in her eyes and the folds
in her clothes.

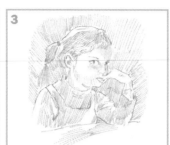
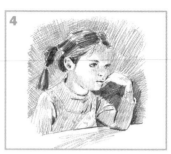

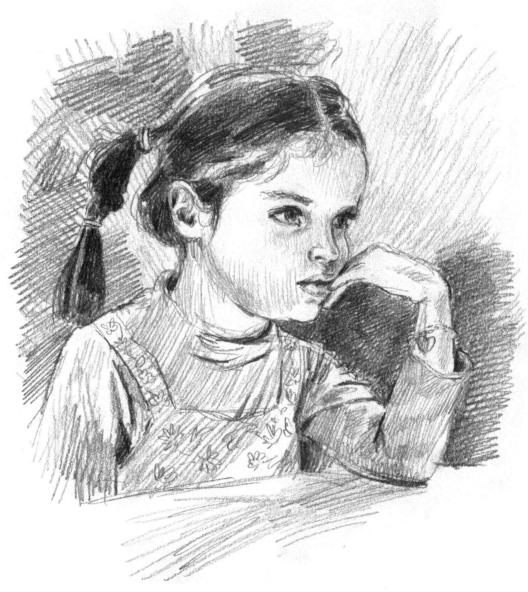

Now blend in all the other tones between the lightest and darkest
until you are satisfied with the result. The light is falling on quite a
large area of the girl's face, represented by leaving white paper.

Using a child as a model for a portrait is never easy, as children do not usually want to sit still for any length of time. Even if they like the idea of posing for a portrait, it is a good idea to photograph them from the same angle so that you can complete the picture if they become bored and want to call it a day.

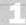

Sketch in the main shapes to help define the drawing area. The particular attitude of the subject, caught in the midst of a task, helps to make the picture more lively. To draw a pose like this you have to be quick because your model will soon look stiff and unnatural if you ask him or her to hold it for long.

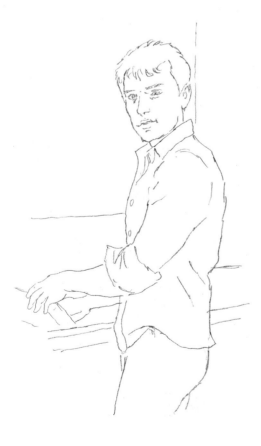

Now, more accurately, draw in the outline of the whole scene. Don't worry if you have to make extensive corrections to get everything right.

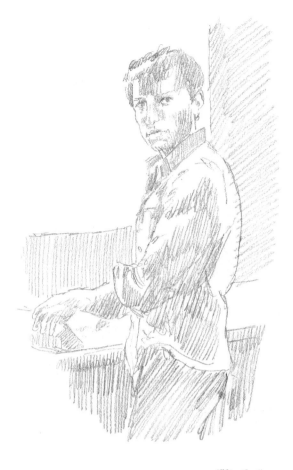

Block in all the areas of shade, using the same light tone.

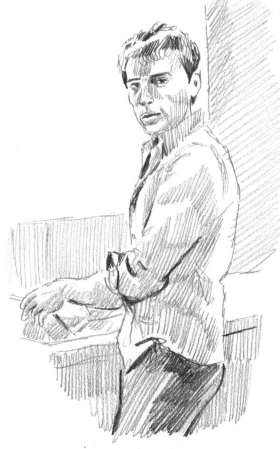

Put in the darkest tones for maximum effect.

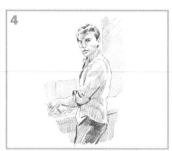

Now blend the tones until the drawing starts to gain life and a feeling of three dimensions.

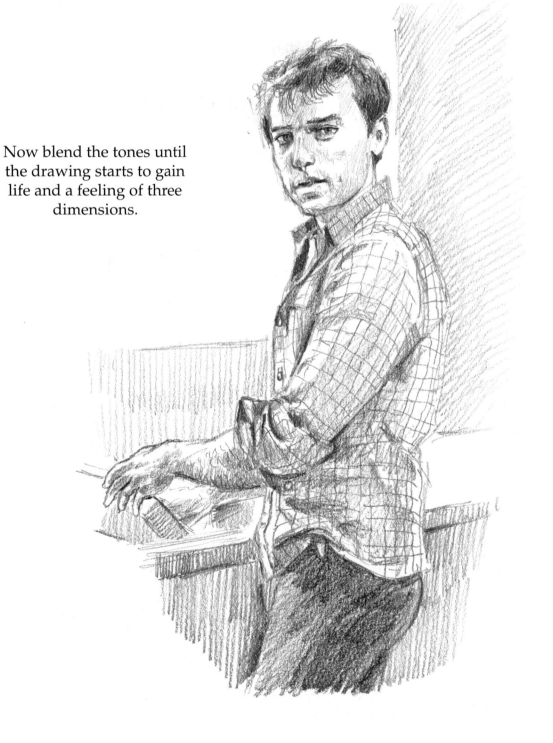

Here the facial expression is quite important, because it helps to
convey the character of the individual posing. It is a good idea
to take a photograph too as expressions change rapidly, especially
when the subject is apparently caught in action like this.

A POTTED PLANT

Make a very loose outline to start with to indicate the main shapes
of the plant and pot.

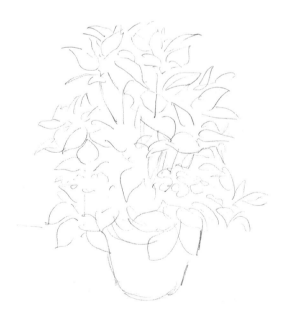

Next make a more defined drawing to mark out the leaves, flowers
and stems and the shape of the pot.

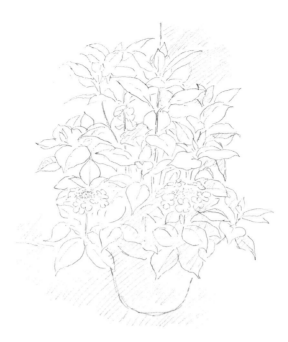

Describe the outlines of the leaves, flowers and stalks more carefully, then mark in quite lightly the main areas of shade.

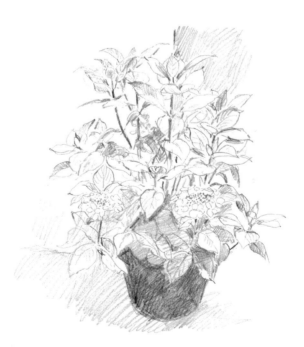

The next stage is to darken some of the tones and begin to show the exact shapes and textures of the plant, pot and background.

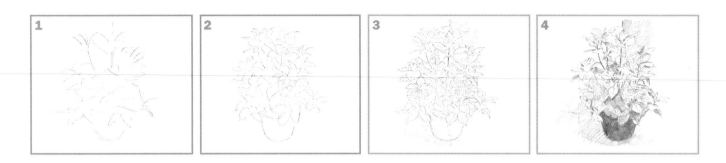

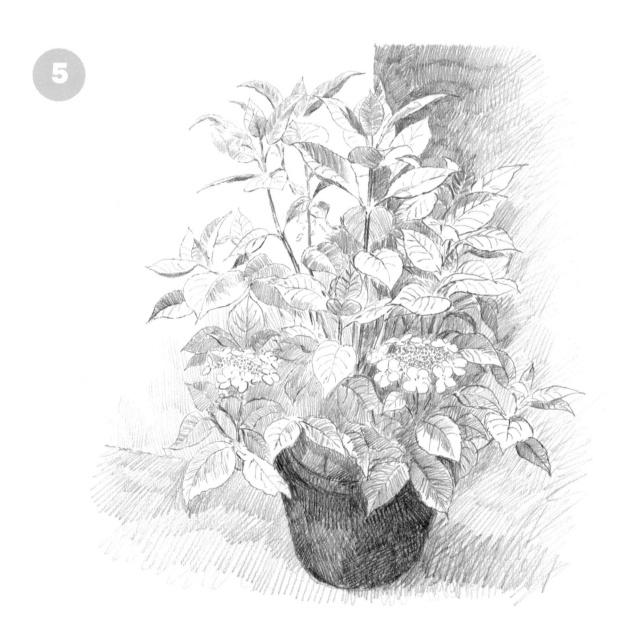

In the final stage you can let yourself go, building up texture and
tone until you are satisfied that the picture looks as much like what
you are seeing as you can make it.

With a subject such as this, you don't have to be totally accurate about the position of each leaf – just attempt to draw the way the leaves point in several directions, sometimes overlapping each other, and notice the gaps between them where you can see the stalks and part of the background.

A WATERING CAN

Draw a rough guide to the main shape and proportion of the
watering can and mark the edge of the surface on which it stands.

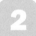

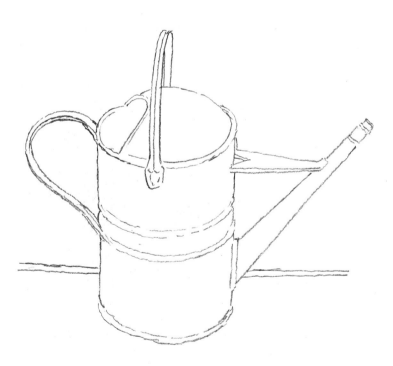

Now draw the outline more precisely, making sure that any mistakes
are erased and corrected before you embark on the next stage.

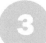

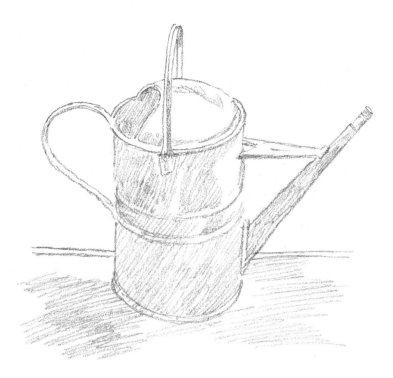

Put in the main areas of tone, using just the lightest tone observable, and reserve white paper for the highlights.

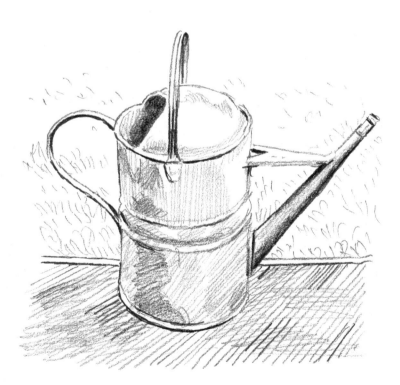

Now put in the dark tones and sketch the lines of the decking quite quickly – don't worry if they are not straight as this will come with practice. Some roughly vertical marks are enough to suggest grass.

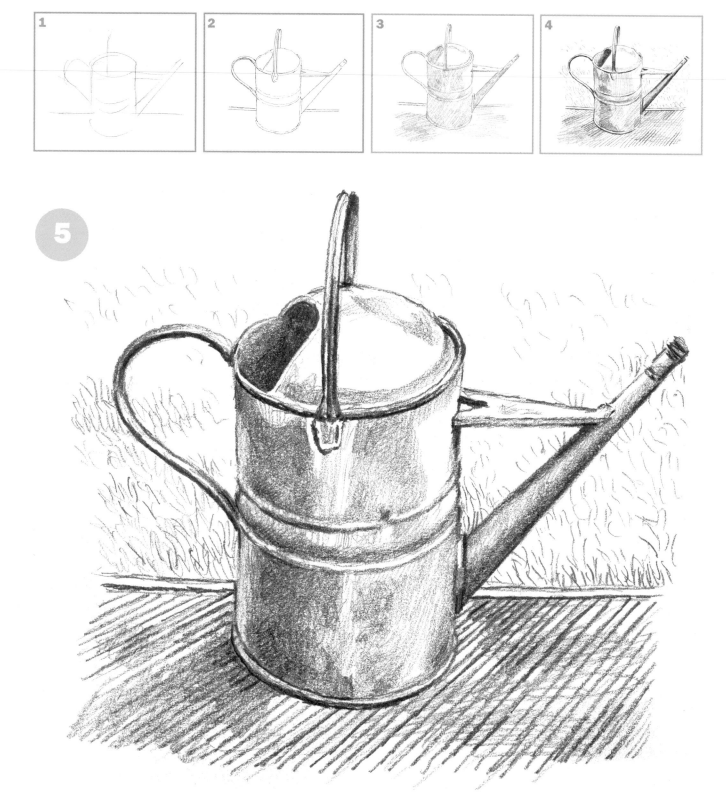

Finally, blend in all the mid-tones to give the watering can a three-dimensional solidity and the decking increased substance.

 Drawing subjects from your garden will usually work well as you can take your time and view them from any angle you choose. Well-used objects such as this watering can or other garden tools and furniture offer textural interest for the artist.

1

Draw a rough shape to indicate the main form of the flower and its leaves.

2

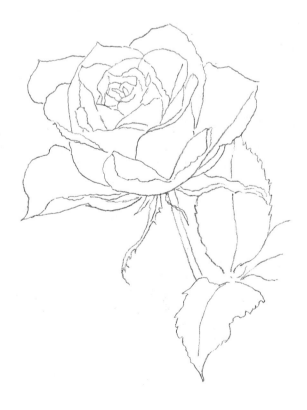

Next, describe more carefully the exact shapes of the petals and leaves.

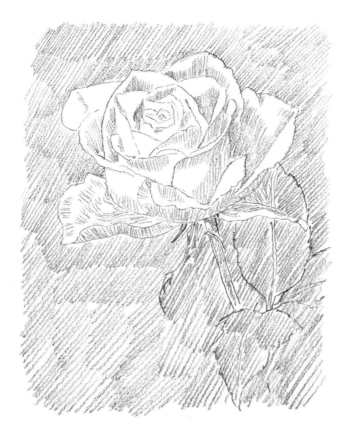

Put a light tone over the whole composition except where you can see there are highlights.

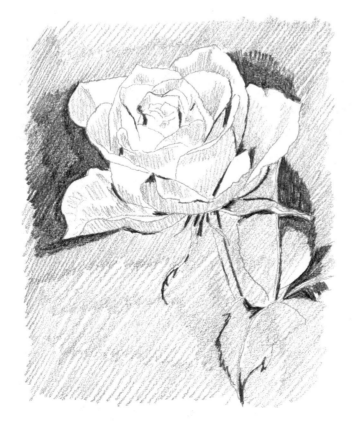

Block in the dark tones behind the flower and add the more linear dark tone on the petals, stem and leaves.

137

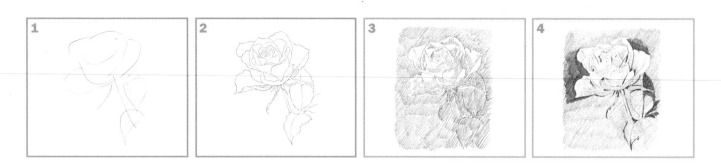

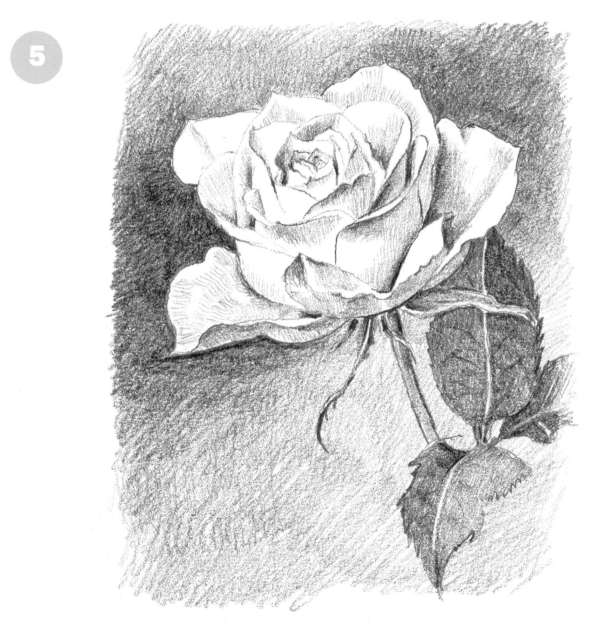

Now blend all the areas of tone until you have achieved a lively and
interesting portrayal of a rose.

It is best to draw flowers in one sitting as they are likely to wilt or slightly change their position and angle in a short space of time. Keep your outline edges as light and delicate as possible to convey the fragility of the petals.

A COTTAGE

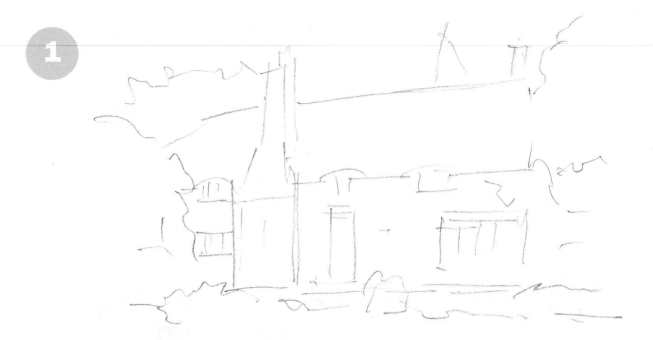

Make a loose drawing to gain a degree of certainty about the shape and proportion of the building.

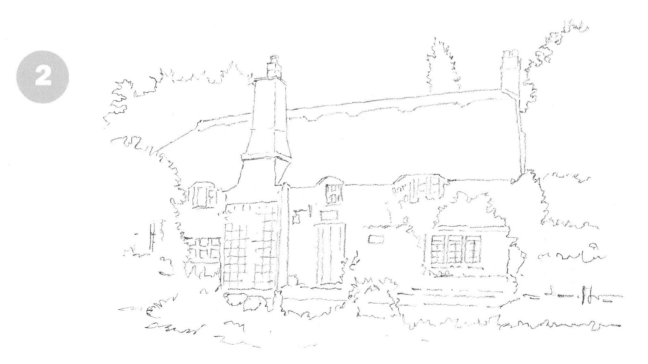

Refine the drawing until you have a fairly accurate feel for the whole cottage and surrounding trees.

3

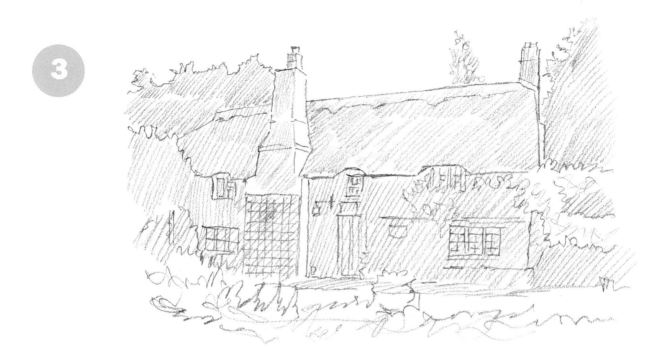

Put in the shaded parts all in one light tone, leaving highlighted
areas as white paper.

4

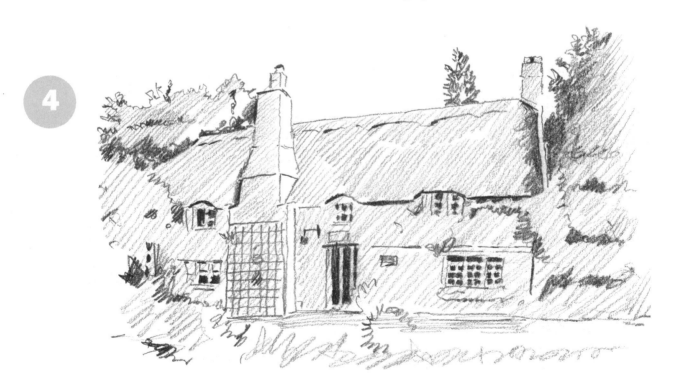

Mark in the darkest tones, which are to be found in the windows and
door and the shaded areas of the trees.

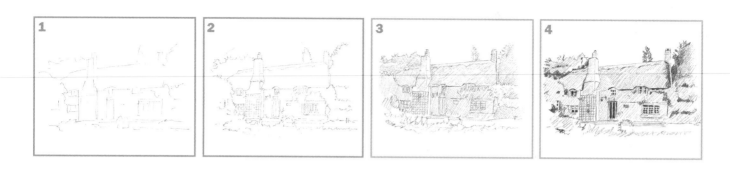

Build the rest of the toning across the whole picture until the cottage and surrounding vegetation are fully realized. To give your drawing a final lift, try rubbing out a few small areas on the front of the cottage to break up the tone.

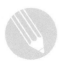 When you are going out and about in the countryside, take a sketchbook with you and draw anything that catches your attention, even if you make just a minimal sketch. This sometimes results in quite an effective drawing because you will probably have noticed something attractive.

A DECIDUOUS TREE

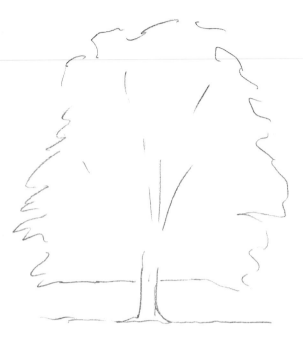

Make an outline sketch to acquaint yourself with the whole shape of the tree. When drawing trees, make sure you are far enough back in relation to their size for you to easily see them in their entirety.

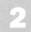

Now make a more careful outline of the tree, showing the way the foliage breaks the skyline and the gaps in the canopy where the branches can be seen.

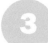

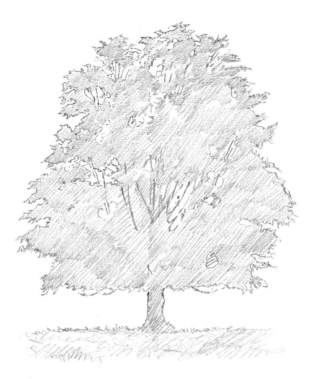

Block in a uniform tone all over the foliage and trunk, as the tree is silhouetted against the light sky. Add the same tone on the grass below it.

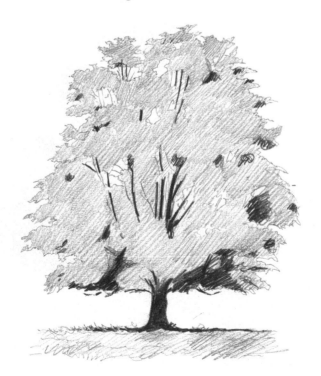

Now put in the darkest tones, especially on the trunk and on the ground immediately beneath the tree.

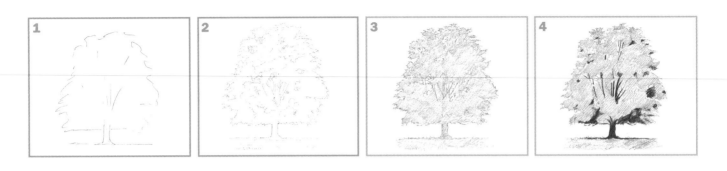

5

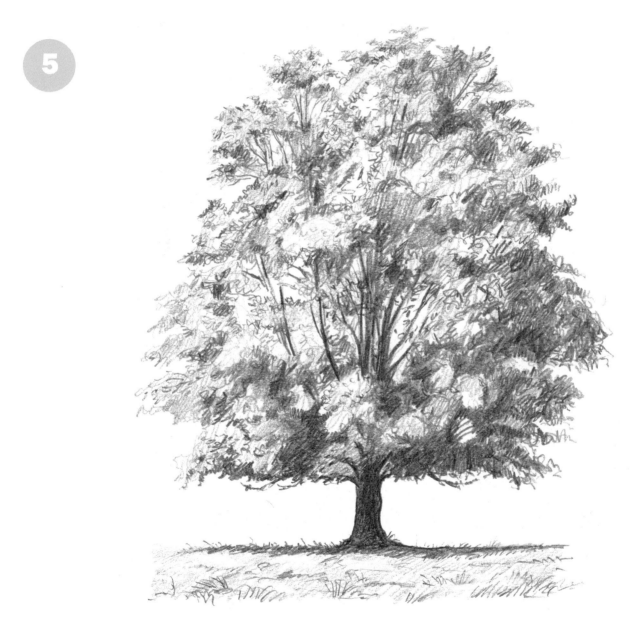

Now work over the whole picture, building the texture of the leaves gradually with variations of tone. You can erase small areas to break up the dark tones.

 With a large, heavily foliaged tree such as this, there is no need to differentiate each branch and clump of leaves – instead, draw areas in masses and the viewer's eye will make the correct interpretation.

A PALM TREE

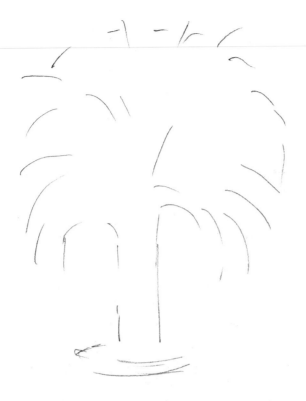

Start with just a simple outline to establish the general shape of the tree.

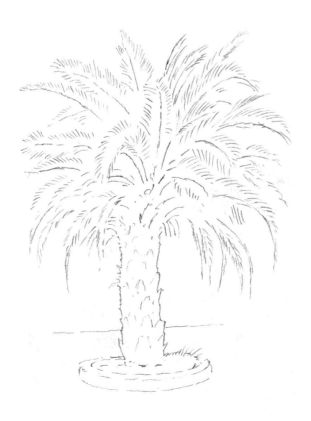

Now draw it in more detail, getting the effect of the branches and characteristic leaves. Define its planting location more clearly.

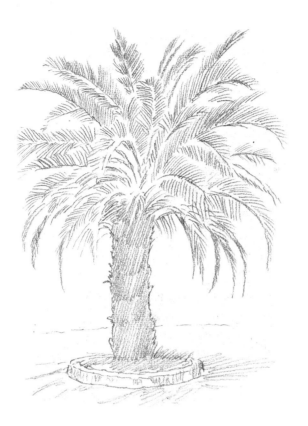

Put in light tone over the whole area except the spaces between the leaves and add the cast shadow on the ground.

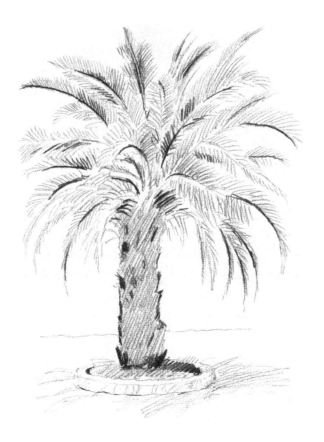

Mark in the very darkest tones next, indicating the shadowed areas beneath the leaves and trunk.

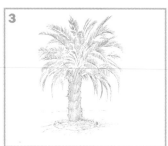
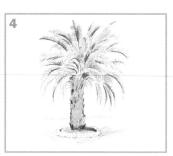

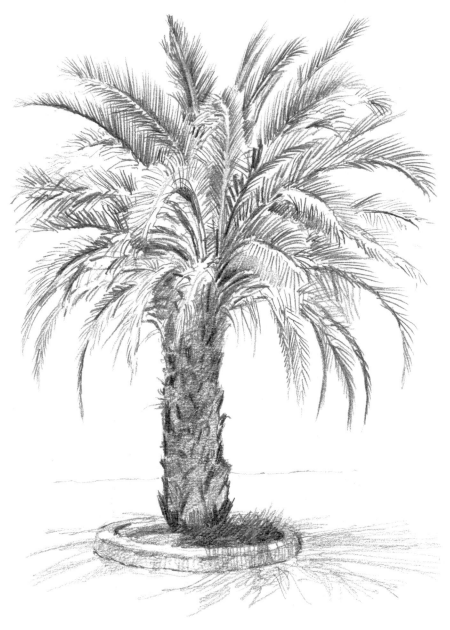

Now, working over the whole tree, build the tones to express the
quality of its textures and shape.

 This type of tree needs careful observation of how the fronds grow out from the trunk, especially those projecting towards you. You will need to leave areas almost untouched to get the effect of the leaves catching the light against the darker fronds behind.

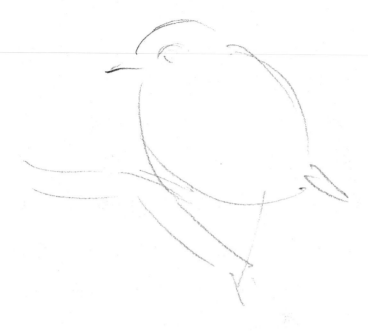

Draw a quick sketch to get the main shape of this bird, which is a little smaller than a sparrow.

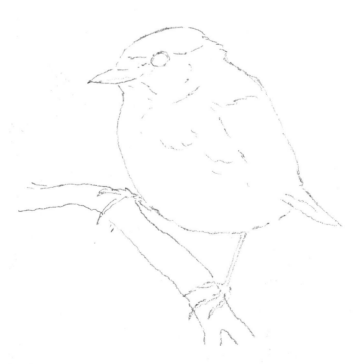

Draw in the bird more carefully, with attention to detail. The legs are barely wider than the thickness of the pencil line, contrasting with the rounded body and head.

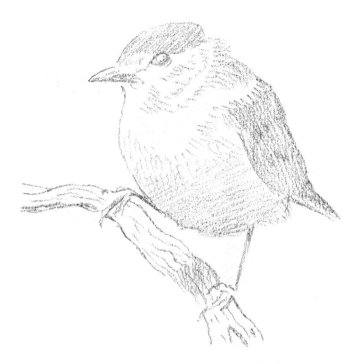

Block in the main tonal areas quite lightly, including the branch on which the blackcap is perching.

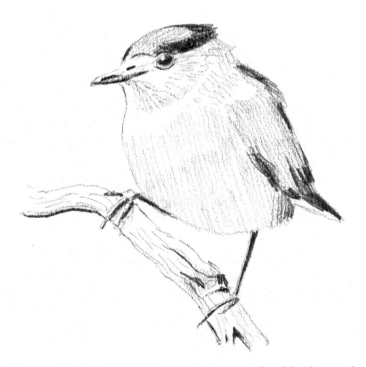

Next put in all the dark tones, which include the black marking on the head from which the blackcap gets its name.

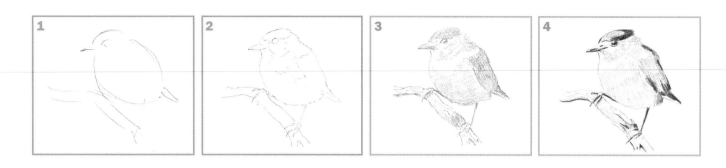

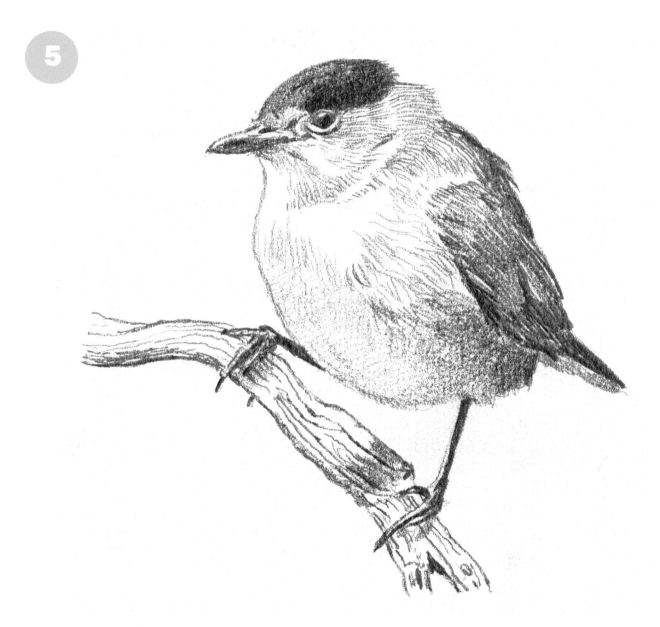

Work over the whole bird in some detail to give a convincing effect of its feathery body and the very different surface of its legs. At this stage I realized that the centre of the bird's black cap was too light, so I added more shading.

 Birds are rarely motionless, so this blackcap was drawn from a photograph. For your own portrayals of birds, you may like to make a tracing from the photograph afterwards to see how accurate you have managed to make your drawing.

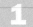

Lightly sketch in the main shape. I worked from a photograph, so that I would have plenty of time to draw the dog's expression and lolling tongue.

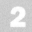

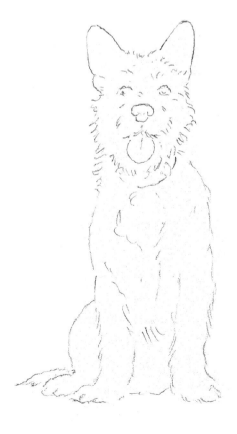

Next, draw in some detail to get the likeness of man's best friend.

3

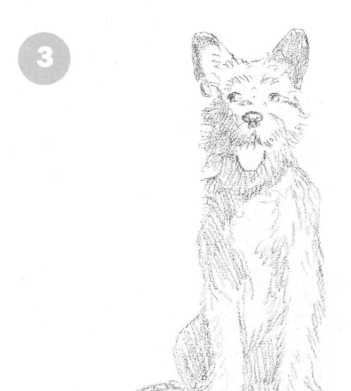

Put in the shaded areas next, using a light uniform tone. Even with a rough-coated dog, there will be areas of highlight.

4

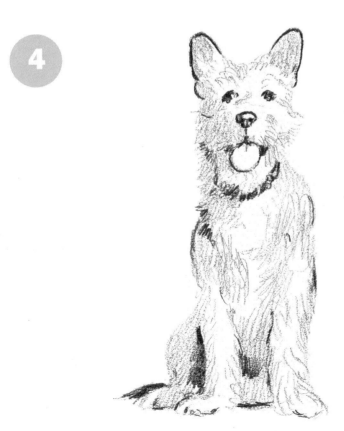

Mark in the darkest tones to help define the dog's shape. The colour of the fur is quite pale, so these are not extensive.

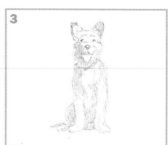
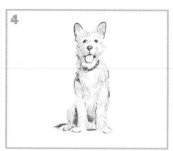

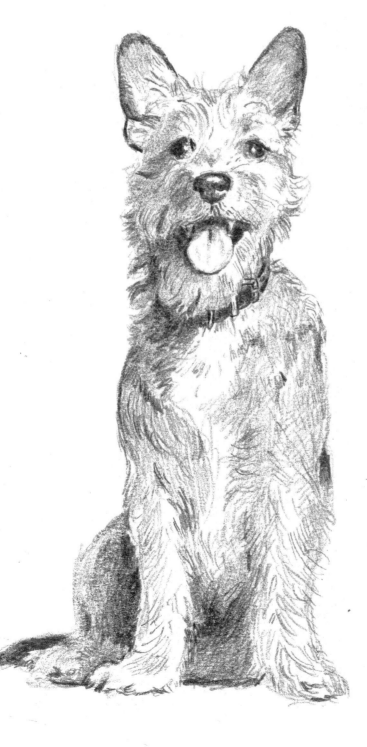

Now work over the whole picture to build up an impression of fur and gleaming eyes and nose. To describe the fur texture, make pencil marks in the direction that the hair grows. This varies over the whole body of the dog.

 Drawing a dog while it is asleep gives you a good chance to make a completed portrait before it moves, but to catch a characterful face and attitude that makes for a really attractive picture of a dog you will probably find it easiest to work from photographs.

A HORSE

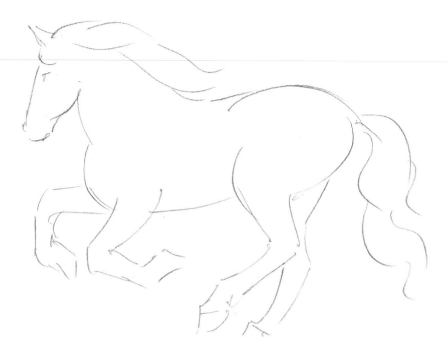

Make a quick sketch to show the main shape. The moving horse is not easy to draw and this was taken from a photograph.

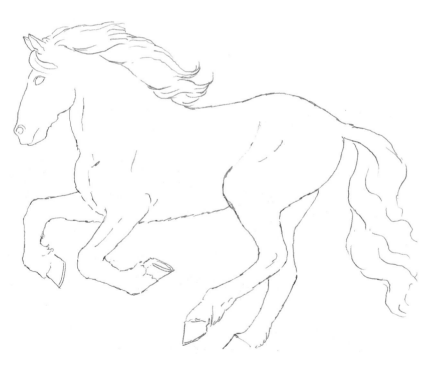

Next comes a careful outline that defines the shapes of the horse's body, legs, mane and tail.

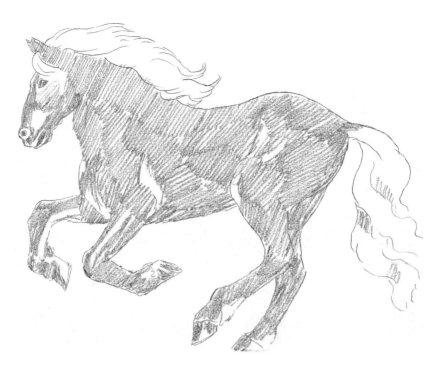

Now add a layer of tone to build the solidity of the animal. Pay particular attention to the highlights around the eye and muzzle, as these will determine how realistic your horse's head will look.

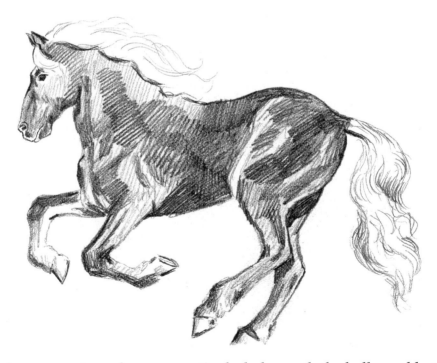

Work in the darker areas strongly now, particularly beneath the belly and between the hind legs. You may have noticed that the rear, right-hand hoof has come off the edge of the paper. This can happen if you draw slightly larger than your paper.

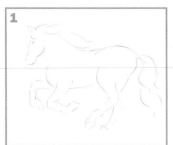
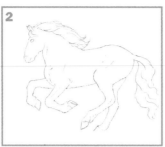
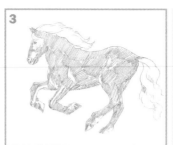
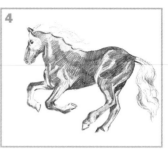

5

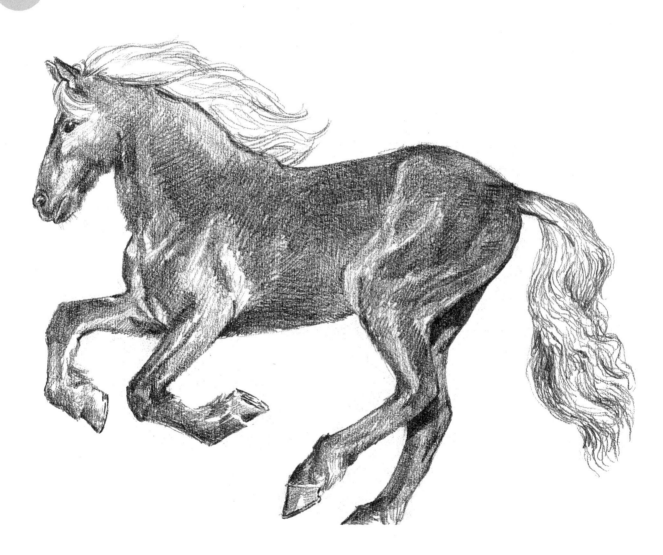

Now work over the whole shape of the horse to create a more realistic effect,
blending your pencil marks to create a smoother look for the horse's coat but leaving
them more distinct in the mane and tail.

 Horses are variable in the details of their conformation as well as their size, so you need to look carefully at your equine models to make sure you are portraying them correctly.

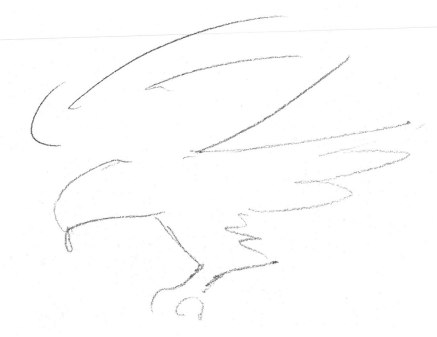

Make a quick sketch to show the size and shape, trying from the start to show the movement in the wings and the dynamic position of the bird.

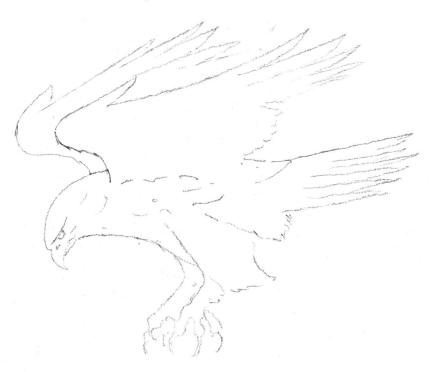

Now make a more accurate drawing of the main outline, including the impressive talons.

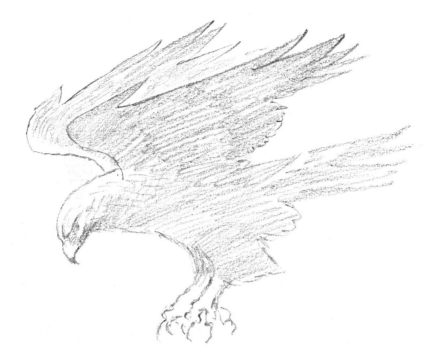

Block in the tonal areas all over the eagle, using a light tone throughout.

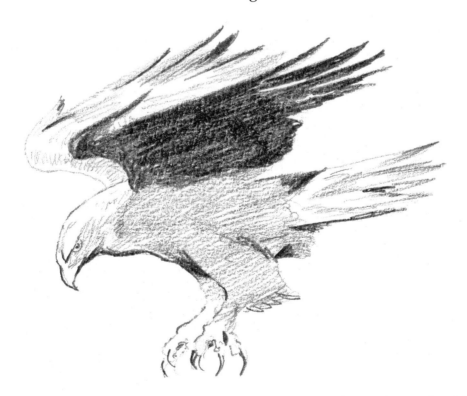

Put in the darkest tones strongly – these are mainly on the underside of the wings and body.

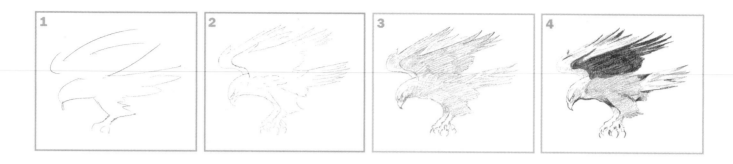

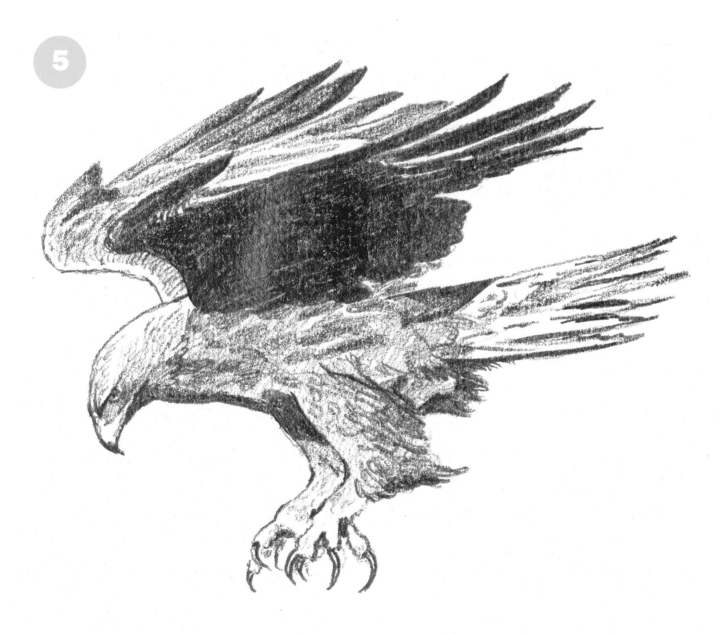

Finally, put in the medium tones which help the light and dark tones
to blend into an apparently three-dimensional form.

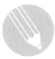 Try to create the effect of movement in your drawing, even when you are working from a photograph. Hatching that follows the direction of movement can help to convey the feel of the bird in flight.

1

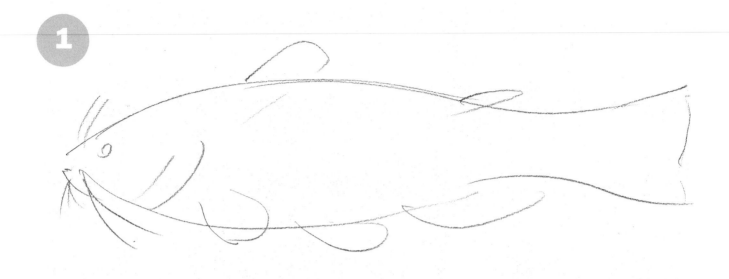

First make a loose outline of the fish, which has an easy enough
shape to follow.

2

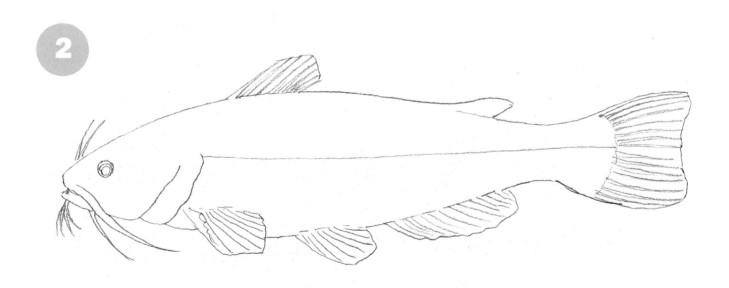

Next make a more careful, precise outline that gives you all the
detail you need.

3

Put light tone all over the fish except for the highlights, which are
essential to convey the shiny skin.

4

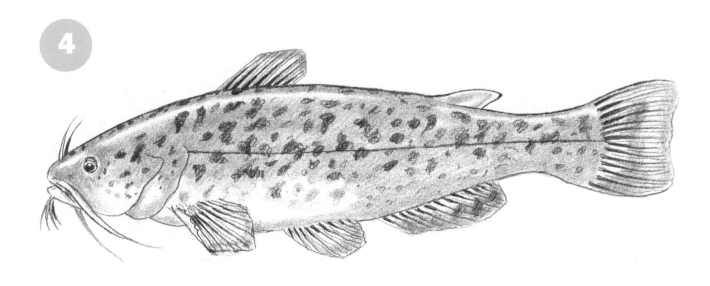

Add the very darkest areas next, to define the fish further. These are
mainly the markings on the skin.

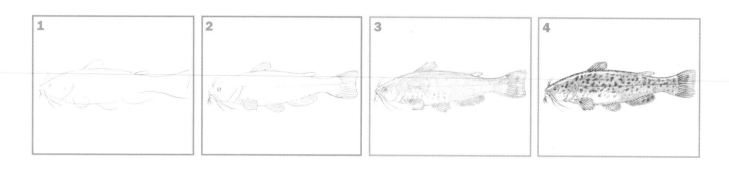

5

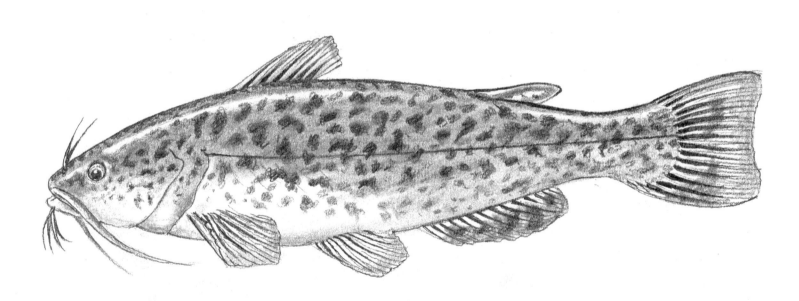

Work the mid-tones all over the fish to give more subtlety to its appearance. To increase the shiny effect of the skin, smudge and blend the softer areas of shade.

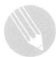 Place a fish on a large plate or slab so that you can see it clearly; you will have to finish the drawing in one sitting as the fishy smell will rapidly increase. Alternatively, draw fish in an aquarium or work from a photograph.

1

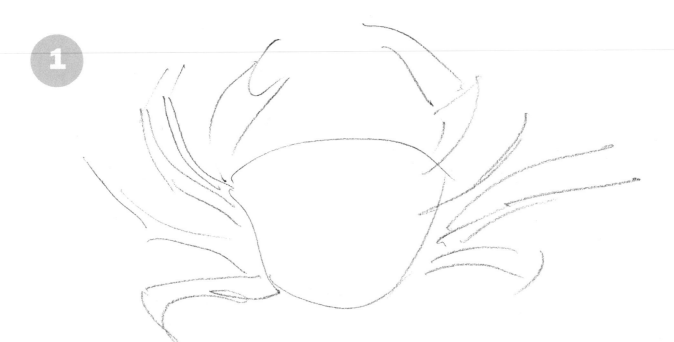

Make a rough outline to find the general shape. The main consideration is to get the angle of the crab's claws and legs correct and in proportion to its body.

2

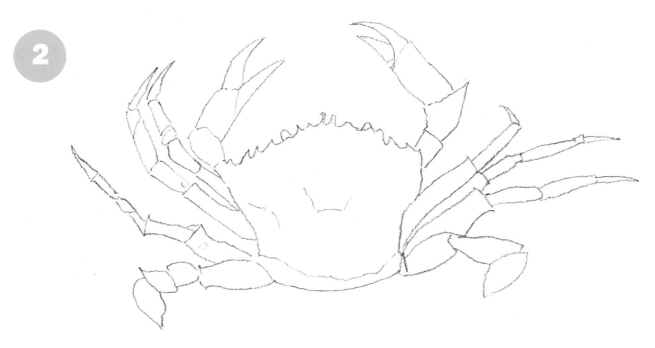

Draw a more detailed outline, getting the shapes as accurate as possible. You should now have what is unmistakably a drawing of a crab, with the characteristic jointing in the legs.

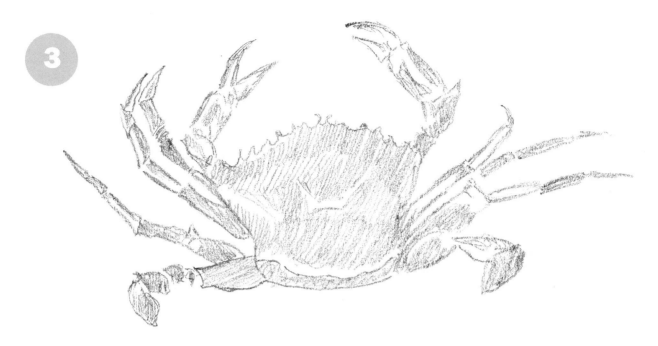

Now add some uniform light tone to start building a three-dimensional feel, reserving white paper for the highlights.

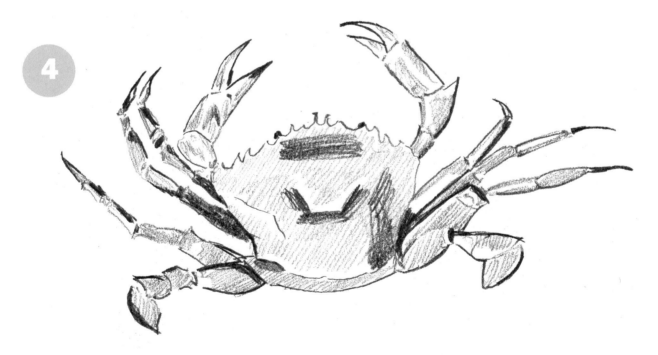

Put in the really dark tones next. These will emphasize the ends of the legs and the tips of the powerful claws.

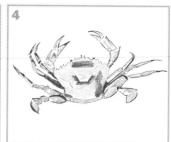

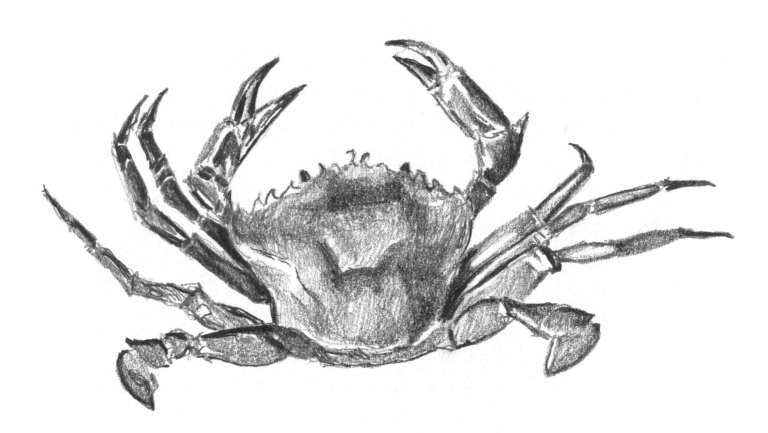

Now work over the whole crab, blending in the mid-tones, until you
are satisfied with your drawing.

 Crabs are easily available from fish markets and fish counters and the best way to really study the detail is to buy one so that you can see the textures on the surface.

A CROCODILE

First make a rough outline of the crocodile's shape, noting the proportion of the huge jaws in relation to the body.

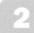

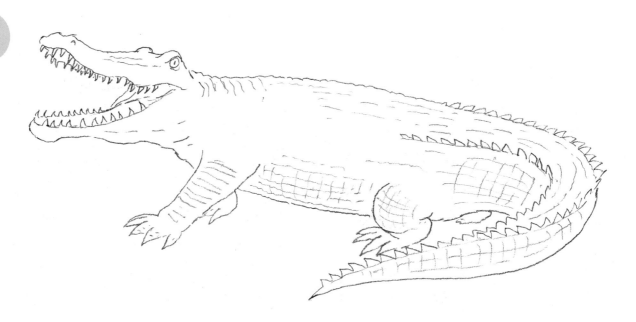

Now make a more careful rendering of the shape and texture, lightly but precisely drawn. The details of the sharp teeth and the scaly fins along the tail are important here.

3

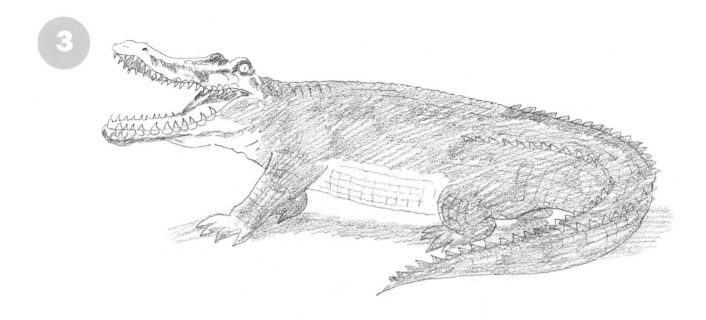

Now block in the main areas of tone, including the cast shadow beneath and behind the crocodile to give it more weight.

4

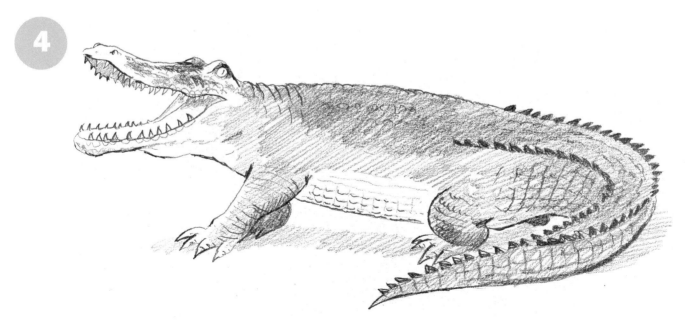

Mark in the strongest tones. The texture of the scales is important here in order to suggest the reality of the animal.

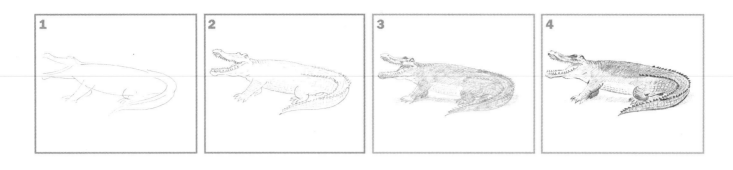

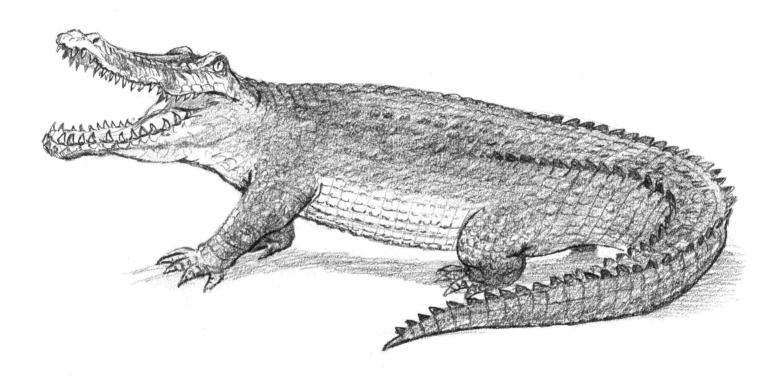

Finally, blend in the mid-tones all over the crocodile to make it more lifelike, with a smooth progression of tone describing its contours and textures.

 If you are not able to draw a crocodile at a zoo, try to take a photograph rather than using one from a book or the internet. Referring to a photograph of your own will remind you of the crocodile's physical presence.

A LION

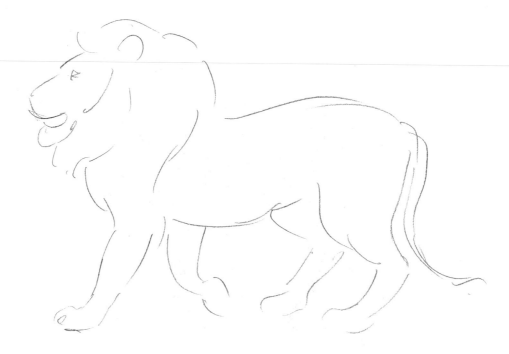

First make a quick sketch to get the main shape right. Working from a photograph is obviously the easiest way to draw this animal; look carefully at its powerful attitude and try to get this down now.

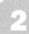

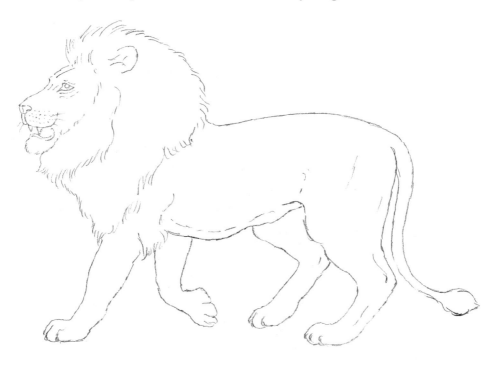

Next make a more careful outline, as accurately as possible. Your lion should now have gained features such as the whiskers and teeth.

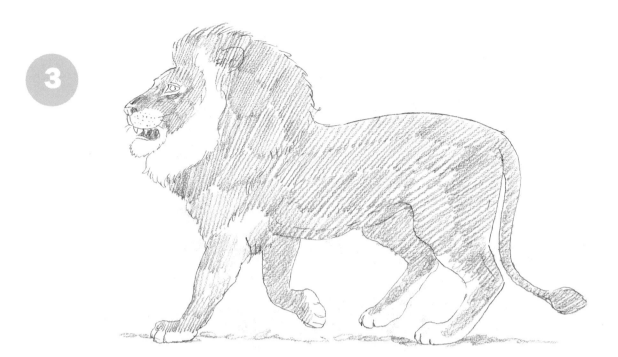

Then put a uniformly light tonal layer over all the shaded areas to start building the solidity.

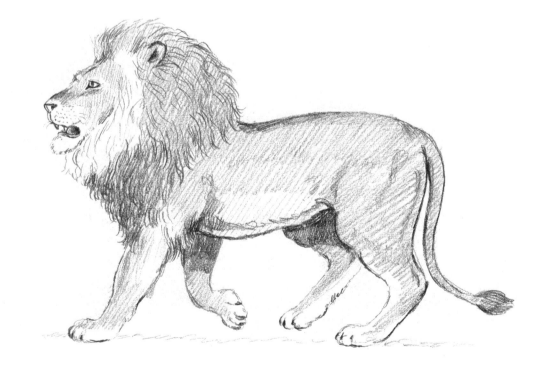

Next mark in the darkest parts more strongly, including more textural detail on the mane to give the feel of the thick longer hair.

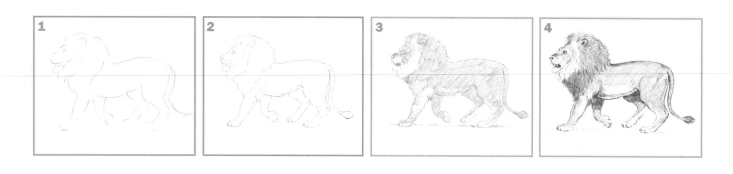

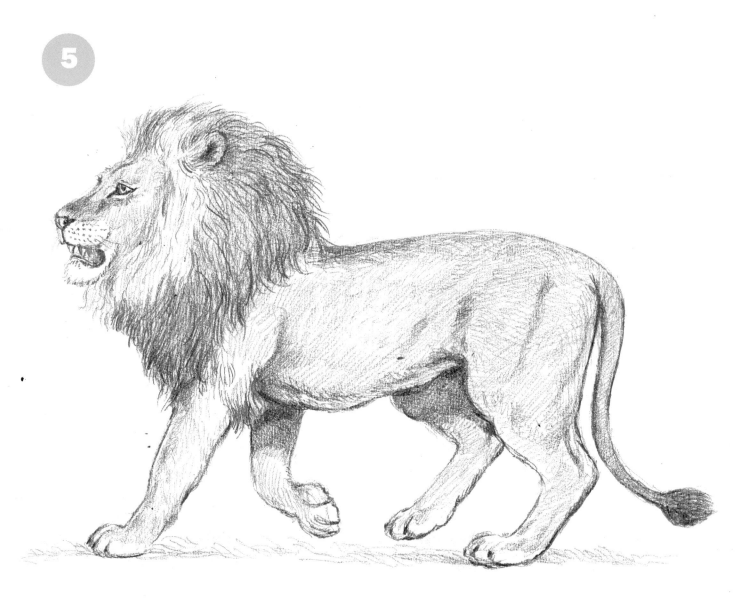

Finally, work over the whole animal, blending mid-tones until you have made the drawing as convincing as you feel you can.

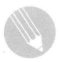 If you visit a zoo to draw lions you should be lucky enough to find them relatively motionless some of the time. Take photographs too that you can use as reference later.

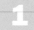

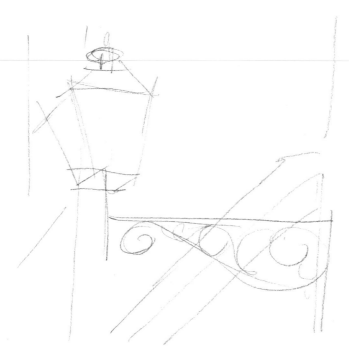

Sketch in the main shape loosely, finding the angles of the structure.

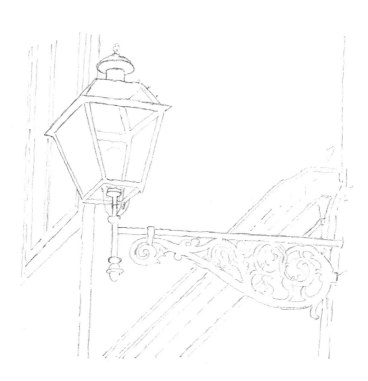

Draw in the whole outline of the lamp and the architecture behind it more accurately, correcting any mistakes as you go along.

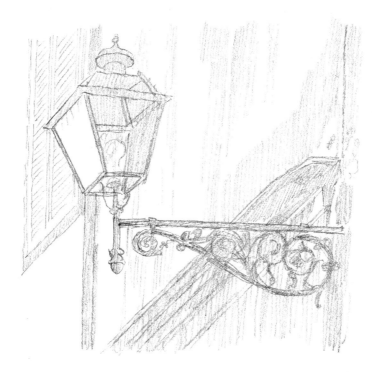

Block in the lightest tone possible all over the areas that have some shade on them.

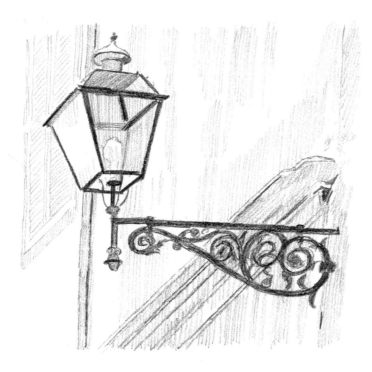

Add the dark tones quite boldly, using them to bring out the decorative wrought-iron pattern.

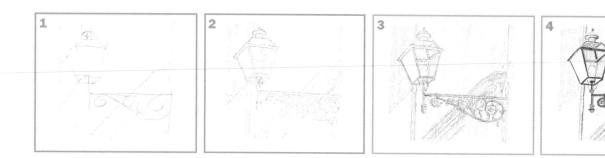

5

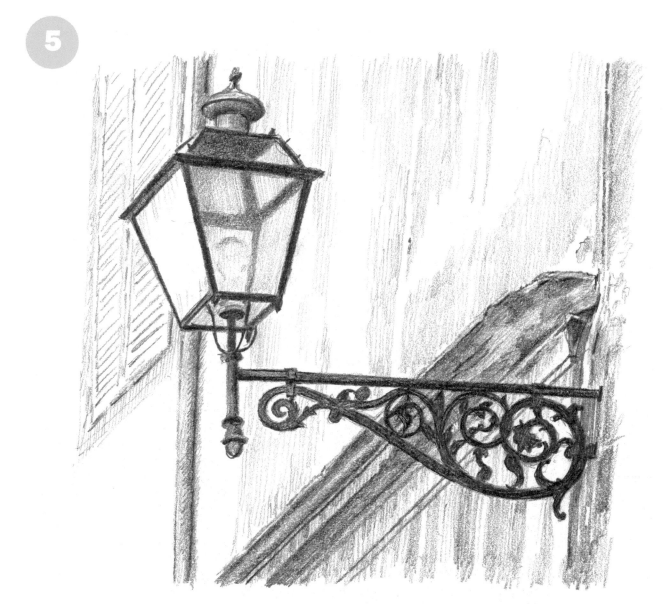

Finally, blend in all the mid-tones to bring the drawing to a
satisfactory conclusion.

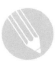 Fragments of urban scenes such as this are interesting to draw but
are often missed, because they are above eye level. Remember to look
all around you to find inspiration in an urban environment.

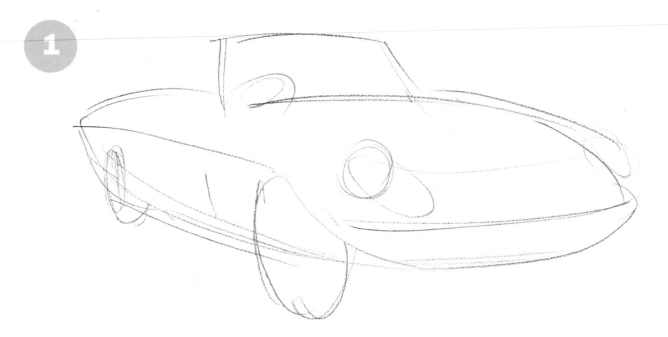

Make a quick sketch to show the main shape. I have drawn the car from a front corner, foreshortening the body and thus making the car look more powerful.

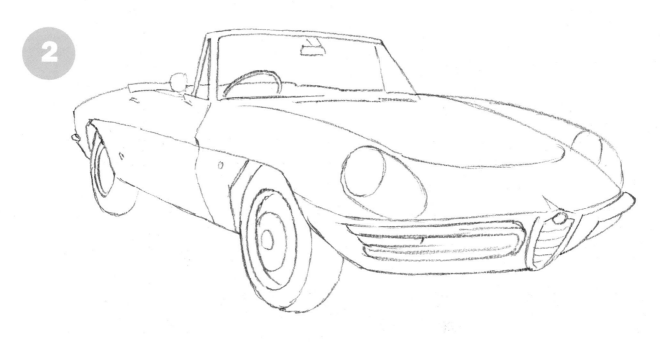

Make a more detailed outline, putting in all the details necessary such as the radiator grille. On a man-made object such as this you need to strive for very even lines.

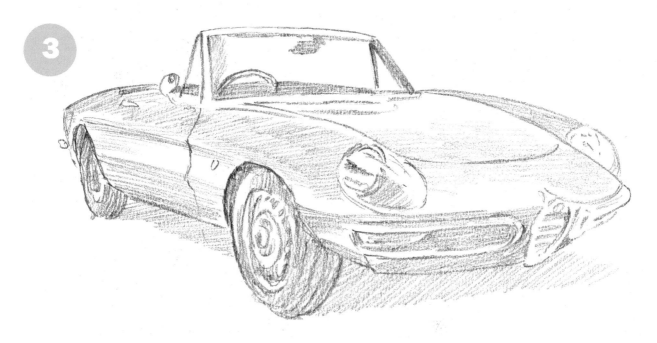

Now block in some light tone to give more dimension to the chassis, leaving white paper for the highlights. Add the cast shadow beneath the car.

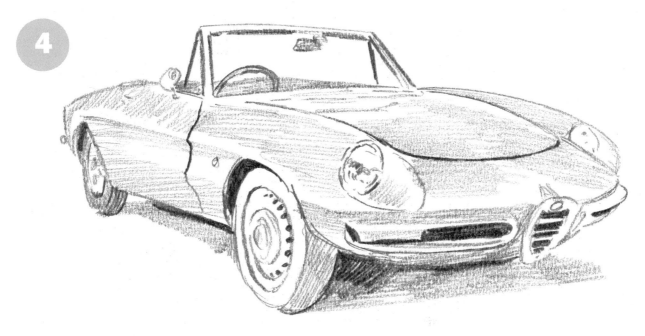

Then put in the darkest tones where the deepest shadows are seen.

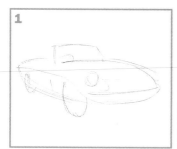
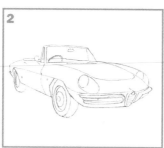
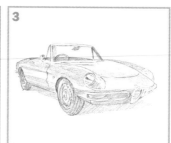
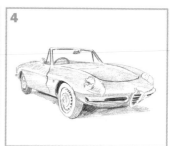

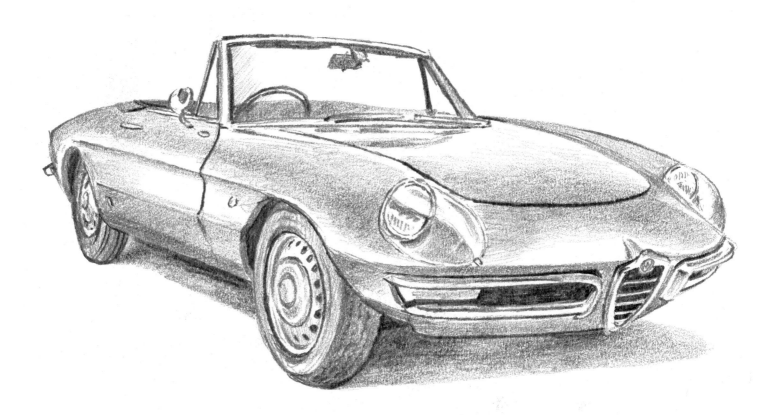

Finally, carefully work over the whole shape, blending in the mid-tones, to get a good-looking version of this glossy machine.

 When you are drawing something finely engineered and pristine such as this car, keep your lines as minimal as possible and the shading carefully graduated to give a slick, smooth appearance.

A MOTORCYCLE

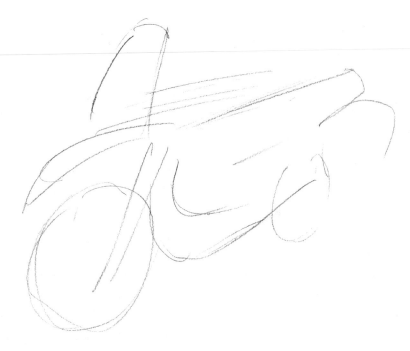

Draw in the main shape loosely. A motorbike is quite a complex subject, but don't worry about all the fiddly details at this stage.

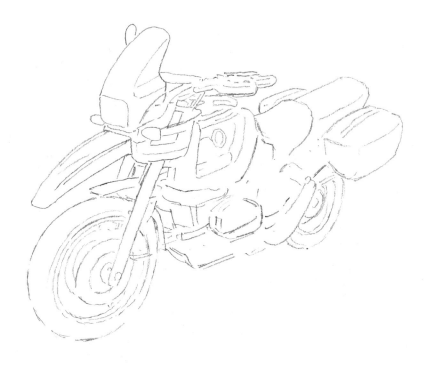

Now make a more detailed outline, taking care to get all the many marks as accurate as possible.

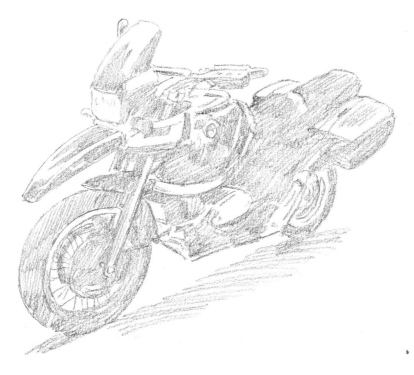

The next step is to block in all the shaded areas in the same light tone and add the cast shadow.

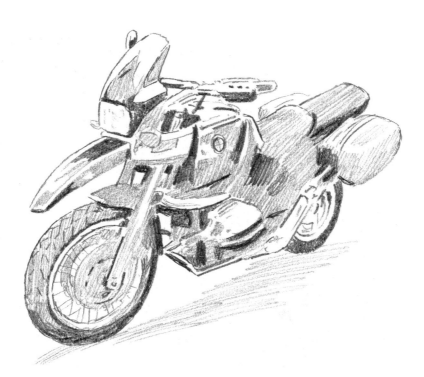

Now put in the darkest areas quite strongly. Your drawing should be looking three-dimensional by the time you have finished doing this.

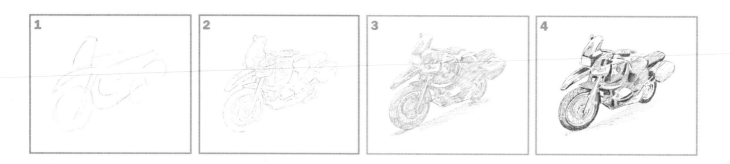

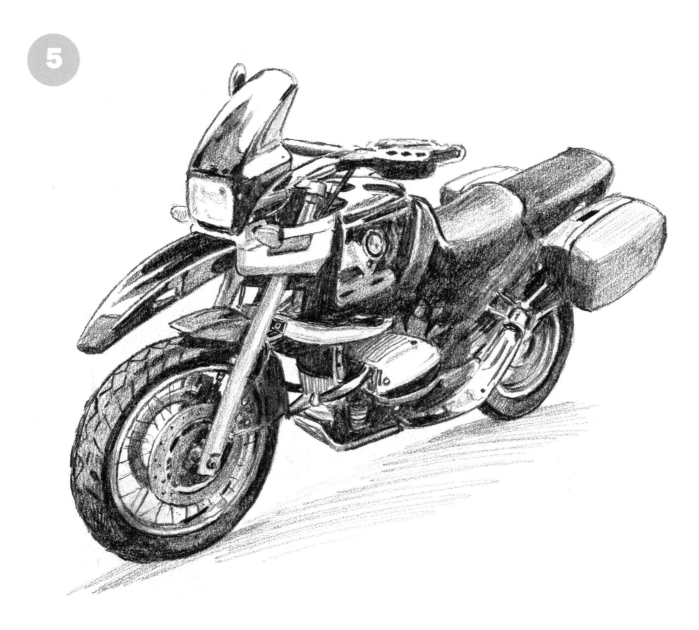

Finish by going over the whole picture, adding and blending mid-tones. Use an eraser to pick out highlights if necessary.

 A motorbike is quite a daunting subject as there is a lot of detail that needs to be drawn, but if you take your time and work methodically you will be pleased with the result.

AN OLD JETTY ON A RIVER

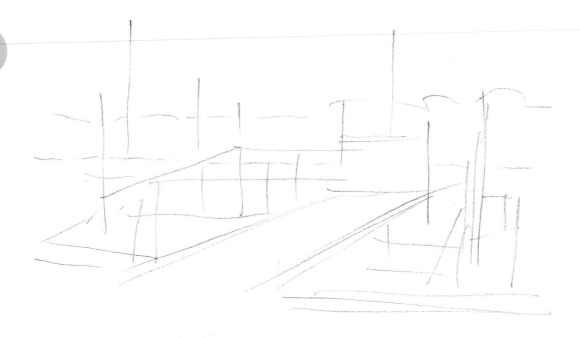

First make a lightly drawn sketch to get the main shapes of the old planks and their surroundings.

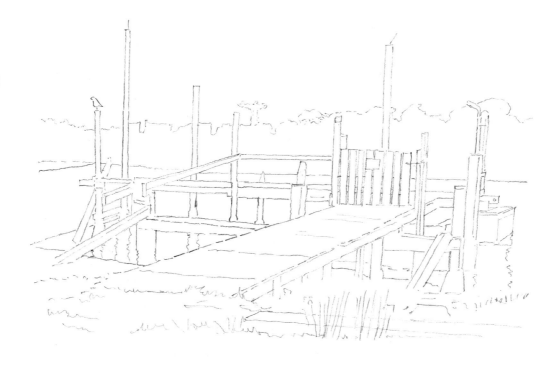

Now make a more detailed drawing of the constituent parts of this rather weathered and old construction. Be as accurate as you can, but it doesn't matter if your drawing is not quite spot on.

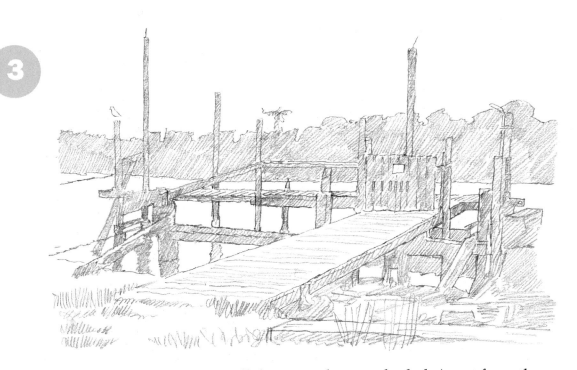

Put in light tone over all the areas that are shaded. Apart from the main ramp there are few highlights on the jetty itself as this is not a very reflective surface.

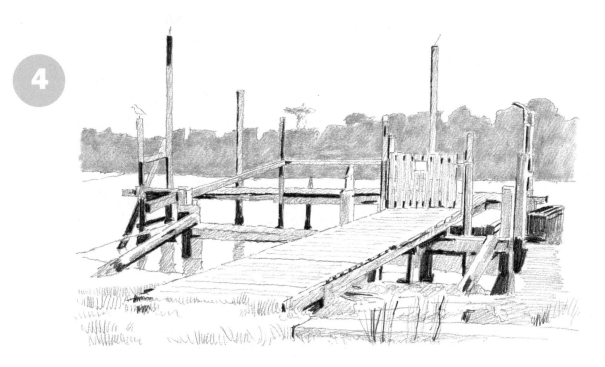

Mark in the very darkest tones and smudge the background of the far bank of the river with a paper stump to soften the tone.

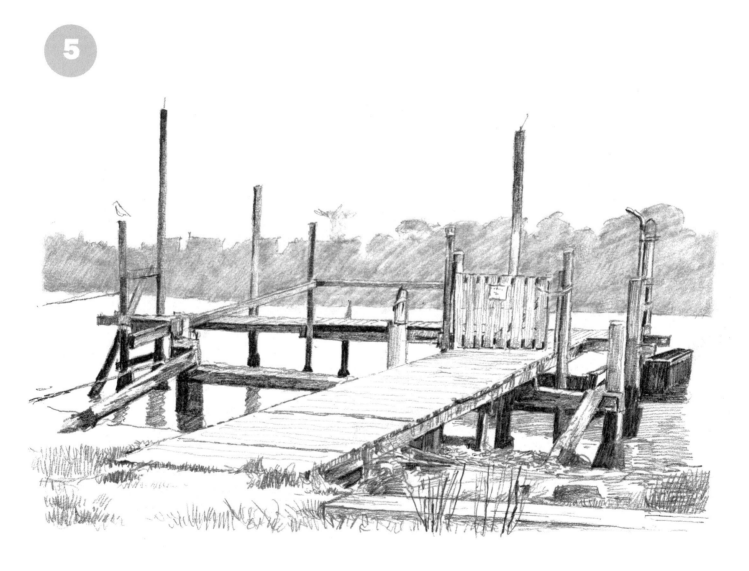

Lastly work over the whole scene, blending tones to get the
maximum effect of solidity and three dimensions.

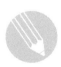 When you are drawing a scene such as this it is not necessary to get everything totally accurate. Viewers of your work will probably not have seen the exact place, so as long as the whole picture holds together it is a good drawing.

A MOTOR BOAT

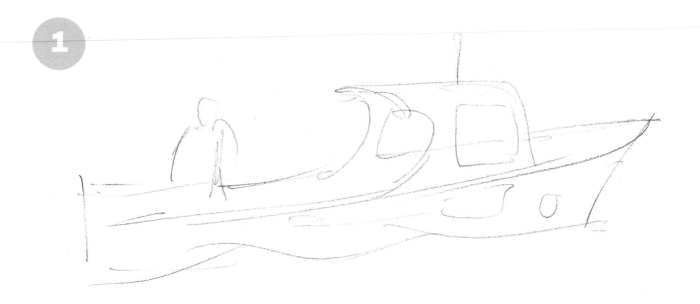

Start as usual, with a sketchy outline to get the main shape correct. Of course the water around a moving boat is moving too, so you will have to decide where to place the shapes of the waves.

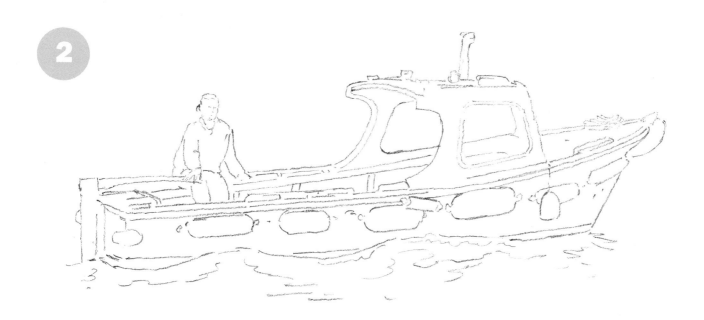

Next draw in the whole picture in outline as accurately as you can, correcting as you need to. Take your time over this.

3

The next stage is to block in areas of shade in a light uniform tone,
leaving white paper for highlights.

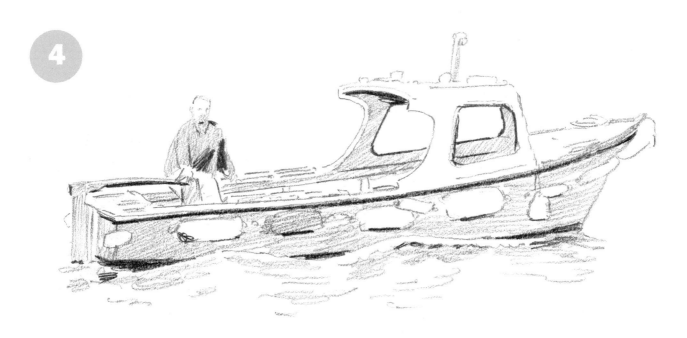

4

Mark in the darkest tones, which are minimal. This is because the sky
was overcast so light was flatter than it would be in full sunlight.

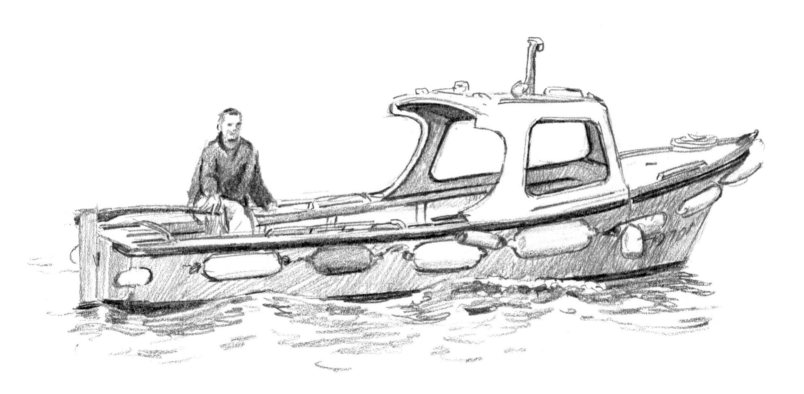

To finish, build the rest of the tonal values until you are satisfied that
the result looks convincing.

A boat is harder to draw when it is moving as the angle may rapidly change, so you may want to take a photograph and work from that. Alternatively, you can draw a moored boat and add the waves and helmsman later on.

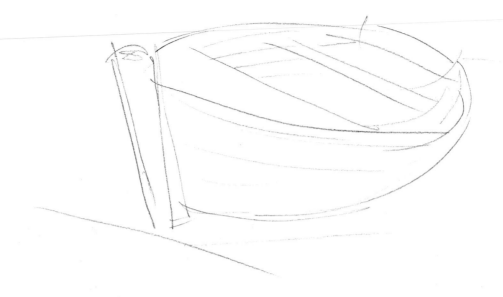

Make a rough outline of the main foreshortened shape of this old and battered boat, drawn up on the shore.

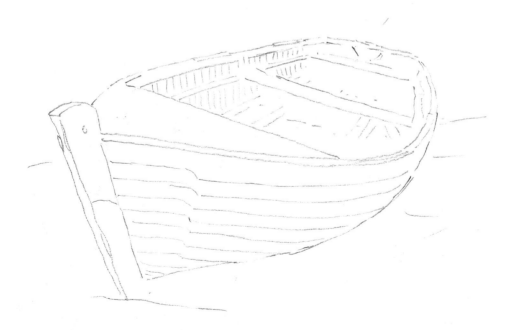

Now draw the main lines more accurately, looking very carefully at the curving shape of the boat.

3

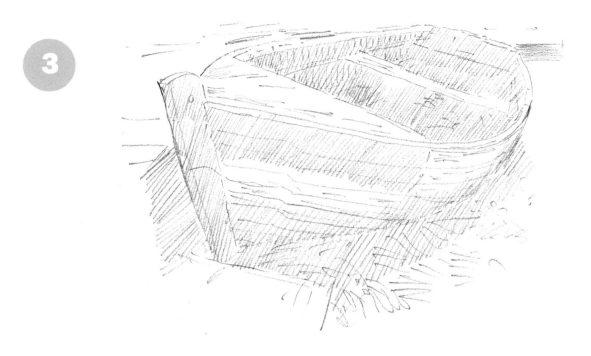

When your outline is correct, put light tone over all the shaded areas
of the boat and the surface around it.

4

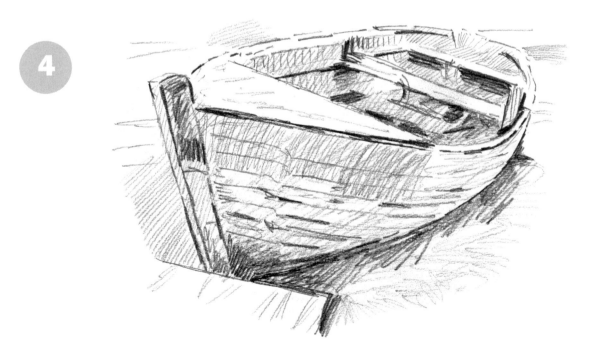

The next step is to strongly define the dark areas of tone on the
boat and the shore.

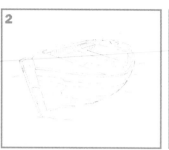
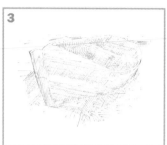
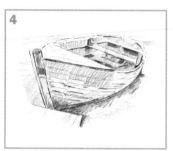

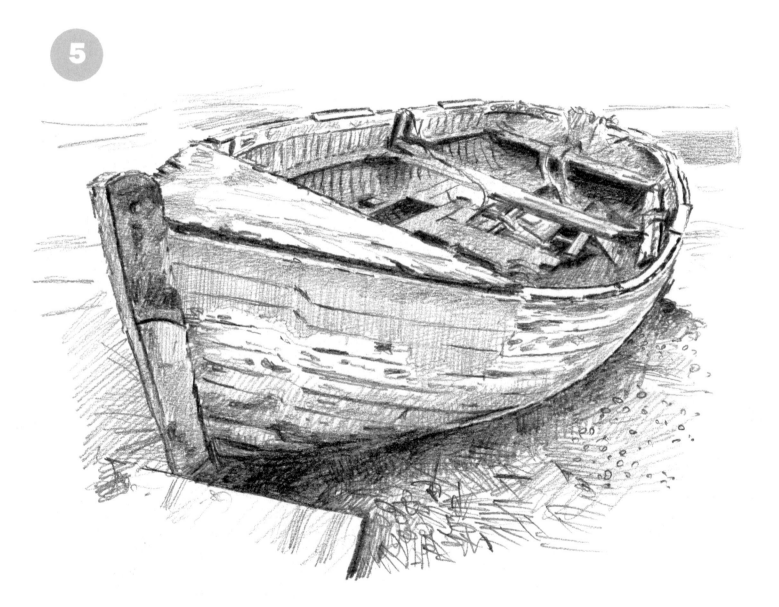

Put in the mid-tones and the more obvious textures to convey the roughened surfaces of this old craft. Treating the immediate surroundings in a similar way completes a convincing picture.

 As this boat shows, it is not always smart new items that are the best to draw. For an artist, battered old objects are much more interesting in terms of their surfaces.